CHARLESTON'S
TRIAL

CHARLESTON'S TRIAL

JIM CROW JUSTICE

DANIEL J. CROOKS JR. & DOUGLAS W. BOSTICK

Charleston · London
THE HISTORY PRESS

Published by The History Press
Charleston, SC 29403
www.historypress.net

Copyright © 2008 by Daniel J. Crooks Jr. and Douglas W. Bostick

All rights reserved

First published 2008

Manufactured in the United States

ISBN 978.1.59629.576.6

Library of Congress Cataloging-in-Publication Data

Crooks Jr., Daniel J.
Charleston's trial : Jim Crow justice / J. Crooks, Jr. and Douglas W. Bostick.
p. cm.
ISBN 978-1-59629-576-6
1. Duncan, Daniel, d. 1911--Trials, litigation, etc. 2. Trials (Murder)--South Carolina--Charleston. I. Bostick, Douglas W. II. Title.
KF224.D86C76 2008
345.757915'02523--dc22

2008030663

Notice: The information in this book is true and complete to the best of our knowledge. It is offered without guarantee on the part of the author or The History Press. The author and The History Press disclaim all liability in connection with the use of this book.

All rights reserved. No part of this book may be reproduced or transmitted in any form whatsoever without prior written permission from the publisher except in the case of brief quotations embodied in critical articles and reviews.

Dedication

This book is dedicated to the two people who first encouraged and inspired us to tell this story.

The late Professor Emmett Robinson of the College of Charleston researched the history of the Old Charleston County Jail and the local traditions concerning capital punishment. He personally encouraged us to tell the story of the murder of Max Lubelsky.

The late Melvin Simmons was chief deputy of the Charleston County Sheriff's Office. On a rainy day in the fall of 1988, he talked about the legend of the Duncan Storm as it had been taught to him by his grandmother.

Both of these men spoke of an injustice, of a wrong that needed to be made right. To that end, we have dedicated our efforts.

Contents

Acknowledgements — 9

Chapter 1	Day of Deliverance	11
Chapter 2	Corrupt but Content	23
Chapter 3	An Israelite Lays Dead	39
Chapter 4	Searching from Uptown to Darktown	51
Chapter 5	A Costly Stroll in the Morning Sun	57
Chapter 6	A Simple Coat and Hat	69
Chapter 7	A Question of Speech	83
Chapter 8	And Nothing But the Truth	97
Chapter 9	Arrest Who They Could Catch	101
Chapter 10	Cheers and Sighs	105
Chapter 11	May God Have Mercy	109
Chapter 12	Jail Bound	111
Chapter 13	Some Hope Be Mo' Den No Hope	119
Chapter 14	Nowhere to Turn	123
Chapter 15	Redemption	125
Chapter 16	Snatched…To Return a Corpse	129
Chapter 17	I Will Not Die with a Lie on My Lips	139
Chapter 18	Wildflowers	145
Chapter 19	The Judgment of Man Meets the Wrath of God	149

Bibliography — 159

ACKNOWLEDGEMENTS

This true story from the turn of the last century had been lost in history. We are indebted to many people who assisted in its recovery.

The staff of the South Carolina Historical Society placed all of its resources at our disposal and graciously responded to a multitude of inquiries. As always, we are indebted to the Charleston Library Society and its fine staff, who helped to unlock the treasures hidden in that collection. Additionally, the South Carolina Room of the Charleston County Library remains an indispensable part of any research focused on Charleston, South Carolina.

Harlan Greene, with the Avery Institute, reviewed early manuscripts and provided us with his expert observations and suggestions. Alphonso Brown contributed to our knowledge and understanding of Lowcountry Gullah history.

Several members of the Charleston Police Department provided technical assistance to the authors concerning evidence and crime scene–processing techniques, as well as homicide investigation. The efforts of Detective Captain Gary Tillman, Detective Sergeant Barry Goldstein and Forensic Science Director Judy Gordon are greatly appreciated.

Charleston police officer Timothy Reed shared with us his collection of Charleston police memorabilia, which allowed us to add to the historical realism of our story.

The Wilton Poulnot Jr. family kindly provided us with family pictures and the opportunity to examine Sheriff Poulnot's first badge of office, given to him by Sheriff Martin in 1904. Our longtime friend Edwin Poulnot III gave early direction to the project and also provided us with useful historical insights about Charleston's past.

Argentini Anderson, former assistant administrator with the Ninth Circuit Solicitor's Office, researched and identified early court records and

Acknowledgements

documents. The office staff of Emmanuel AME Church, with the assistance of Reverend LaVerne Witherspoon, provided the authors with photographs from church and congregational archives.

A special thanks to Norman Lubelsky, Joseph Lubelsky Jr., Dolly Lubelsky Young and Kate Georgia Lubelsky. The surviving grandchildren of Max and Rose Lubelsky met early on with the authors, providing us with photographs and memoirs. Their recollections of Max and Rose allowed us to personalize their lives. We greatly value their kindness and friendship.

Prior to his retirement, Rabbi David Radinsky provided us with a concise and compelling history of the Orthodox Jewish community in Charleston.

We are indebted to the late Dorothy Moultrie for taking the time to sit with us in the reception area of her funeral home, sharing the stories told to her by her grandmother about Daniel Duncan and the Duncan Storm. As a quiet protest, she and her siblings were raised to never walk directly in front of the Lubelsky store.

Young Ward Nichols, only ten years old in this story, ultimately became the senior bishop of the African Methodist Episcopal Church. Prior to his death, he agreed to meet with us to share his firsthand account of the events that occurred on July 7, 1911. The detail and precision of his account demonstrated a memory that was still sharp and clear, despite his advanced age. His recollections added measurably to this story.

Finally, we would be remiss if we did not thank the two people who have stood with us, encouraging us and allowing us the freedom to pursue our passions. To our wives, Lynn Crooks and Karen Bostick, thank you for your patience and love.

CHAPTER 1
Day of Deliverance

Friday, July 7, 1911

The morning sun began to rise, illuminating the port city of Charleston. From the east, the city seemed to ascend from the ocean, a North American Venice. As the first rays of light pushed across the harbor, the silhouettes of the many ships at anchor began to appear. The multitude of songbirds and sea gulls began to awaken and set out on their daily search for food.

The "honey dippers" had already made their rounds, empting the privy vaults through town; they had removed the waste from the vaults bucket by bucket, leaving a deposit of lime behind to stifle the stench. On their wagon, loaded with barrels filled from the privies, two black men eased down Queen Street, anxious to be finished for the night.

As the mule pulling the waste continued on its journey to the Phoenix Sanitation Company, it was clear that the two men were merely passengers aboard the pungent wagon. Sharing a libation after a long night's work, each man prayed they would reach their destination before the sun began to heat the day, rendering their cargo all the more intolerable.

Adger's Wharf was already a witness to the activity of the day as men started the arduous task of moving massive cotton bales aboard ship. Smokestacks were already burning, anticipating a morning launch to New York, delivering cotton to the Yankee factories.

The City Market was full of activity as butchers readied their fresh cuts of beef, chicken and lamb. The Charleston eagles, known elsewhere as buzzards, were waiting on the rooftops, hungry for the scraps that would soon be discarded in the streets.

Adger's Wharf at Charleston Harbor. *Author's collection.*

Loading cotton at Adger's Wharf. *Courtesy of Danny Peterson.*

Day of Deliverance

The men of the "mosquito fleet," a flotilla of small boats and dinghies operated by both island and city blacks, were offloading their early catch. Oysters, crabs and fish filled each boat, leaving scant room for the fishermen. Dozens of porgy, a prized sort of chub, filled the baskets. After sorting their daily stock, strong black men pushed overloaded carts filled with the delights of the sea through the city, chanting their familiar cry, "Swimpee, swimpee, I gotcha swimpee!"

The farmers from the Sea Islands had arrived by boat under the cover of darkness, bringing the full array of vegetables that were available in midsummer. Street hucksters bartered for provisions, which they would carry in large baskets balanced on their heads, selling produce to the households of the city.

The early morning in Charleston was a sensory experience. There was a collision between the foul smells from the streets and the pleasant, enticing aromas from the bakeries. The air carried a scent of cinnamon as hungry local customers sought out their favorite breads and cakes. Bellmen from the nearby hotels and inns hustled to select the best pastries for their overnight guests.

Though the Geilfuss Bakery was in full operation, Rudolph Geilfuss was in a dark mood. This would be a hard day, but he would push through it like a good German. As customers came into the popular bakery, they worked hard to not make eye contact with the proprietor, not knowing quite what to say to him.

The city's diners were serving early breakfasts to anxious customers. There was an excitement in the air today. A perverse excitement to be sure, yet Charlestonians couldn't help but get caught up in the adrenalin rush of the day's agenda. Children were intent on escaping from the watchful eyes of their mothers. Businessmen and bankers had kept their calendars clear for the day. Shopkeepers were busy instructing their clerks so they could leave to join in the crowd. They all intended to be present at the jail today.

At the Charleston County Jail on Magazine Street, the sun was not high enough to shine over the twelve-foot wall surrounding the jail grounds. As the skies lightened, a young black inmate was awaking in his canvas hammock, strung high in his six- by nine-foot cell. He hung the hammock high deliberately, hoping to catch some bit of a breeze that dared to enter the small, barred window to the large room occupied by many smaller iron cells. In July in Charleston, however, there was never enough of a breeze to combat the sweltering heat, nor was there a prayer of clearing the stale, offensive odors of a jail with so little ventilation. This jail was built for security, not for comfort.

Reverend Green was a street huckster in Charleston who sold vegetables on weekdays and preached on Sundays. *Courtesy of Roulain Deveaux.*

Day of Deliverance

Street huckksters were common in early twentieth-century Charleston. *Courtesy of Roulain Deveaux.*

Charleston's Trial

The inmate didn't feel the same excitement as the many Charlestonians intending on coming to the jail early this morning, hoping to get a glimpse of him. Nonetheless, this was a special day for him as well—it was a day he had been convinced would never arrive, yet it had been foretold for more than a year.

A guard had been stationed directly outside of the man's cell for the last several weeks, keeping a suicide watch. All night, a gas light was aimed into the cell so the attending guard could be sure the man did not deprive the state of the satisfaction of hanging him. The light kept the prisoner awake most of the night, so he just lay in his hammock and watched as the guard snored and grunted.

Captain Patrick Hanley was also up early, checking on his charges. As county jailor, Hanley had the ominous privilege of both living in and working at the jail on Magazine Street. He and his wife, Marcella, lived in the apartment at the north end of the jail. Hanley supervised the operation of the jail, and his wife, with a trustee, was responsible for feeding the many prisoners on the meager budget provided by the County of Charleston.

As Captain Hanley made his way to the condemned man's cell, the guard reported the prisoner had slept well during the night. Hanley wanted to be sure that everything was in order before Sheriff J. Elmore Martin arrived, a man he both feared and respected. Sheriff Martin had emphasized his clear desire for a well-run execution.

Charleston had not witnessed a hanging for five years. In a city where public hangings had been commonplace for centuries, Sheriff Martin disliked the unpredictability of a large crowd assembled to observe an execution. It was his practice, as in the previous hangings that occurred under his term, to conduct the executions within the courtyard of the old jail.

This execution was different, though. The violent nature of the crime had left many citizens in fear during the long investigation and search for the killer. Given the state of race relations in Charleston in the early twentieth century, the murder of a white man, even if he was a Jew, by a black man had the attention of the entire community. This kind of violence just did not occur in Charleston.

As the prisoner stretched to stare through the small window, he could see the gallows awaiting him. Yet he didn't seem to fear his appointment with death. He explained to anyone who would listen that his pastor, Reverend Nichols of the Morris Brown AME Church, had prepared him well for this day.

Below, at the gallows, a rehearsal was going on. A deputy motioned to an unseen presence in the executioner's box. Orders were barked out, followed by a second of silence. A sack of grain was raised high into the air and then

Charleston County Sheriff J. Elmore Martin (left) and Deputy Sheriff Joseph Poulnot (right) signing Poulnot's Oath of Office. *Courtesy of Wilton Poulnot Jr.*

dropped. The bottom of the sack split open and the feed corn poured across the ground.

The prisoner ate a good breakfast of eggs, bread and milk prepared by Marcella Henley in the jail's apartment kitchen. The guard on duty, and even the other prisoners, muddled through a meal of grits and fatback while watching him. They had all expected to see some sign of anxiety or desperation, but there was none.

The prisoner's father, along with his two sisters and brother, visited him early in the morning, offering prayers and goodbyes. The meeting was filled more with tears and long stares than with words. Everything had already been said for months now. The great anxiety over the judgment of the court and the constant hope for a miracle that would never arrive left the family exhausted and despondent.

They were instructed to visit and leave early, ahead of the crowd that was expected to assemble. Sheriff Martin had already advised them that he would not have them present for the hanging. The inmate's family brought him his black suit, white shirt and black tie to wear for this special occasion.

As the family left, they could see the crowd, almost exclusively white, assembling on the streets. The group of armed deputies, escorting the family, made it clear to the spectators outside the jail that they would not tolerate a disturbance today.

Children, black and white, had taken to the tree limbs and rooftops, stretching and leaning forward to see what they could. On the Franklin Street side of the jail, children of Jenkins Orphanage huddled in the chapel. Reverend Daniel Jenkins read quietly from the Bible, admonishing each young man in his charge to take full note of what was unfolding.

By 9:00 a.m., a small parade of black men reined in their carriages at the front of the jail. Dressed in high white collars and crosses, the men endured jeers and name-calling as they filed into the prison. The sheriff had anticipated this visit by the black ministers. A guard summoned Captain Hanley to announce the ministers' arrival. Two deputies stopped to attend to the situation, pausing to wipe sweat from their faces. Their badges glistened as the hot sun rose in the tenth hour.

One of the ministers, Reverend L. Ruffin Nichols, handed the reins to his young son Ward, telling him to stay put until he returned. As several angry white faces pushed forward, Reverend Nichols warned his son to keep his mouth shut no matter what was said to him.

The other ministers passed quickly through. One by one, Reverend MacMillan, Reverend Mitchell and Elder Holton from Morris Brown AME Church gathered at the bottom of the stairs. Soon, they were followed by

Day of Deliverance

Reverend Bonneau, a Methodist pastor, and Reverend William Deveaux, pastor of St. Luke's Reformed Episcopal Church. As the first deputy surveyed his charges, the other searched each minister thoroughly. Reverend Nichols hurried through the gate and joined the enclave. With eternity so close for the man to whom he had ministered for so long, Reverend Nichols felt the full weight of this last, important task. As a symbol of solidarity, not one, but six clergymen would escort the condemned prisoner to his death.

The ministers walked up the stairs into the dark hallway. The walls were wet, as though sweating. The air was thick; the railings slick with moisture. As the group reached the second landing, Elder Holton stumbled and reached for the rail. A guard suggested that Holton go back, but Reverend Nichols would have none of it. He, too, reached out and, together with MacMillan, helped Holton to the third floor.

As many times as Reverend Nichols had visited this prisoner during his incarceration, he never grew accustomed to the jail and its foreboding atmosphere. The stench of the prison made an immediate impression on any visitor to the jail. The reverend often wondered how the white jailor and his wife could make their home in such a place.

With the few windows and confined hallways, little natural light invaded the confines of the jail. The prisoners were divided amongst the three levels by the severity of their crimes. White prisoners and blacks charged with minor or nuisance crimes were housed on the first floor. Prisoners awaiting trial and those marked for transfer to the prison farm and chain gang were held on the second floor. The third floor, given the name Mount Rascal in the 1850s, held most of the black prisoners, particularly those accused or convicted of violent crimes or awaiting execution.

As the ministers walked up the stairs in the dark hallway, a sick feeling overcame them. This jail, in continuous use since 1804, was not a place to rehabilitate people; it was a place of lost hope, a place of despair. Yet they were determined to provide comfort, reassurance and hope to the condemned man in his last hours.

They finally completed their walk up to the third floor. The jailor opened the iron-barred door leading into the forty-two- by thirty-six-foot room containing ten cells. The trustee from the first-floor cells, who had the unenviable task of emptying the slop buckets containing remnants of inedible food and human waste, had just completed his rounds. Moving and dumping these buckets from each cell filled the room with an unimaginable odor, surpassing the normal stench that hung in the building like a dark cloud.

In Mount Rascal, the prisoners ate, slept and defecated in a cell of fifty-four square feet, surrounded by other cells of similar size. There was no

privacy in the large, open room. Most prisoners were not afforded the privilege of exercise or time in the jail yard outdoors. The only sport enjoyed by the prisoners was following the movements of the ants, cockroaches and rats that had inundated the old building. They passed their time by watching the few rays of sun that dared to enter the jail move across the room as the day progressed. During summer in Charleston, most of the daylight hours were spent looking forward to the evening and some small relief from the oppressive temperatures.

The prisoners had already begun their day filled with monotony and boredom. Visitors were rare on the third floor of the jail, so the unusual activity in the cell room was a welcome relief to the typical solitude.

The condemned man was clearly happy to see the ministers, greeting each man warmly. As the preachers stood in front of the solitary cell, other prisoners turned away or bowed their heads. Each preacher took his turn reading a passage from the Bible.

Suddenly, loud voices and heavy footsteps penetrated the solemn space. The ministers turned to meet Sheriff Martin face to face. He was accompanied by the assistant jailer, Captain Charles Rice and Officer Strobel. After acknowledging the ministers, Martin dismissed his men to join Hanley downstairs for one final inspection of the gallows.

Sheriff Martin, not wanting to publish a schedule for security reasons, had kept the time of the hanging a secret from even his men. Seeing that everything was in order, the sheriff instructed the jailors to have the prisoner dressed. His pastors stayed as the young black man dressed in his black suit, white shirt, collar and tie, readying himself for his appointment.

Sheriff Martin was required by legal formality to read the death sentence aloud. Pulling a sheet of paper from his coat pocket, Martin opened it and read, his voice calm but deliberate:

> *By order of the State Court of South Carolina, you have been found guilty of the crime of murder, and have been sentenced to be executed today between the hours of ten a.m. and two p.m., and hang by the neck until you are dead.*

As if the order were the first verse of a musical round, each minister began his own response in hushed prayer. Soon, seven voices joined in a chorus of condemnation and praise. The sheriff ended the impromptu service with a quick directive in an officious voice, and silence settled unevenly over the crowd.

Strobel unlocked the door, and for the first time in nearly a month, the condemned black man was allowed out of the cell. Rice attached leg irons

and then commanded him to put his hands out in front for the handcuffs. The prisoner's legs were weak and unsteady.

The shackled prisoner looked toward Strobel and asked if he could say goodbye to Lofton Hansley, a man in a nearby cell who had befriended him while in jail. Hansley, a black man from "5 Mile," was charged with the murder of a black man who he had found in the company of his girlfriend. Soon, he too would face trial.

The two men shook hands and exchanged words of encouragement. Surely Hansley must have wondered if this same fate was awaiting him and if watching his newfound friend preparing for death was only a glimpse of himself at some future date. As Sheriff Martin took charge, Reverend Bonneau offered one last prayer.

The prisoner, flanked by Martin and Nichols, entered the dark hallway of the third floor. Sheriff Martin had a firm grasp of his arm, while Reverend Nichols tried to comfort and reassure him. Martin's grasp was not there to prevent escape, but to steady the prisoner as he shuffled along.

The jailors and the other ministers followed them as they approached the first of two sets of steps descending to the first floor. Seeming appropriate for a place like a jail, each flight contained thirteen steps. The descent to each level was necessarily slow, but uneventful, as the threesome continued arm in arm.

After living in his small cell without the benefit of exercise for a year, the walk down two flights of stairs left the prisoner exhausted. Sweat was rolling down his face and his shirt was soaked through.

The entourage finally arrived at the ground floor and stepped into the jailor's office on the northwest corner of the building. In the crowded office, six expert observers, appointed by the sheriff, concluded the formalities by announcing that the prisoner was sane and ready to meet his fate as prescribed by the Charleston County Court. Of course, this declaration was not made with the benefit of any questioning or examination. The archaic state law required such a declaration, so Martin was determined to provide it.

The manacles on the prisoner's hands were removed, and his arms and hands were bound, by rope, tightly to his side. This would prevent his arms from flaying about as the noose did its job. Sheriff Martin nodded, and Captain Hanley opened the door to the west courtyard.

Peering through the door, the prisoner was momentarily blinded by the bright sun. He had grown unaccustomed to so much light while being held in the dark confines of the jail. After standing still for a moment, his eyes began to adjust, allowing him to see the jail yard. To the left, he could see Mrs. Hanley's garden, laden with vegetables ready to be harvested. Today,

there were more pressing matters, and the tomatoes would have to hang from the vine for one more day. To the right, near the jail wall, he saw a stand of wildflowers in full bloom. Bees and butterflies competed for the sweet nectar, unaware of the mortal events about to unfold. With Sheriff Martin pointing the way, the young man began his walk to eternity.

CHAPTER 2
CORRUPT BUT CONTENT

By the turn of the twentieth century, Charleston still had not caught its breath after the War Between the States. The social upheaval and economic devastation following the war left a wake that had engulfed the former "Queen City of the South."

Charleston was a city accustomed to great wealth. The white and free black citizens of this great city-state were people of privilege. Unlike many of the other colonies in early America, Charles Towne was a business venture for the Lords Proprietors, who owned and governed the colony pursuant to a royal grant. While often referred to as the "Holy City," it wasn't so much that Charles Towne was a bastion of religious freedom as it was that everyone and anyone was welcome who might contribute to the economic success of the settlement.

Timbering the great live oak trees was a big industry in Charles Towne. Prized for its tensile strength, the oak was favored in shipbuilding. While there were shipyards in Carolina, most of the best oak was sent to the shipyards of the New England colonies. Pine trees were harvested for naval stores, producing tar, pitch and turpentine. The timbering of the region was followed by cattle ranching.

It wasn't until rice cultivation began, however, that the real wealth descended upon Charleston and its outlying plantations. By the end of the eighteenth century, Sea Island cotton found a home on the many islands along the coast from Charleston to Beaufort, making its financial contribution as well.

In postwar Charleston, the plantations were slow to return to production. Many of the experienced white planters were killed during the war or died of natural causes during the difficult period of the 1860s. With the plantations' labor force now free and, in most cases, pursuing their own interests, South Carolina cotton and rice plantations were, for the most part, left in the hands

of a young, inexperienced generation. They found themselves burdened with the responsibility of restoring their family fortunes. With little, if any, cash, there were few assets to mortgage with the cotton and rice brokers. Unlike their ancestors, this generation would have to pay for labor. In the end, cotton and rice, the delivery engines for the great wealth of the antebellum period, would never again produce harvests close to their prewar levels.

After the war, Reconstruction dictated a Federal military occupation of the city. Charleston endured the presence of Yankee soldiers in the streets through 1876, but it was a difficult period for white society and white business interests to withstand. The controversial governor's election in 1876 placed Confederate veteran General Wade Hampton in the statehouse and returned South Carolina to "home rule." This ended the ten years during which the governor's seat was occupied by a Northern Republican. After this election, white Democrats controlled state and local government for the next century.

Yet, while white Democrats had a firm stranglehold on elected office throughout South Carolina, the Democratic Party in Charleston might have best been described as four parties within one. The "Broad Street Ring" was the group supporting Mayor Goodwyn Rhett. This group was composed of the affluent members of the city, referred to by other parties as the aristocrats, and was largely made up of Presbyterians, Methodists and some Episcopalians. They were anxious to seek new industry and federal funding for projects. Believing that vice in Charleston would be impossible to eliminate, they sought to "control" the drinking, gambling and prostitution in the city. Interestingly enough, this group was the least racist, preferring to simply ignore blacks.

The second group was made up of former aristocrats, mostly Episcopalians. They had little use for anyone or anything from outside the boundaries of the Confederate South. They opposed the introduction of any new industry, believing that "King Cotton" and rice would bring Charleston back to its former glory. They were leery of any federal funds and distrusted both the federal and state government. The changes sweeping the country in the twentieth century left them uncomfortable. They often chose to withdraw from politics, finding the process disgusting. Many of this group had inherited their property and "grand" homes that had begun to crumble, but lacked the financial capital to assertively pursue their business dreams.

The third group, led by Sheriff J. Elmore Martin, was best described as "Tillmanites," a nickname used to refer to their allegiance to and belief in the policies of former Governor "Pitchfork" Ben Tillman, who served from 1890 to 1894. This group, made up of the fundamental and Pentecostal

R. Goodwyn Rhett, mayor of Charleston. *Courtesy of the Charleston County Public Library.*

sects, Baptists and Lutherans, was anti-aristocrat and anti-Catholic. While certainly no faction of the Democratic Party was pro-black, the Tillmanites were the most racist, adamantly in favor of segregation and the Jim Crow laws. In 1910, 30 percent of the white Charleston population was of German descent. Like Tillman, they favored an aggressive stance on crime in general, but were also anxious to tackle the issues of drinking, gambling and prostitution, a stance that left them unpopular with the other factions of the party. The strength of the Tillmanites was found in the artisans and white working class of the city and county.

Understanding the political landscape, Police Chief J. Elmore Martin resigned his post in 1898 and stood for election as Charleston County sheriff. Easily elected, Martin controlled county politics for the next twenty years. Any candidate for county-wide office had to secure the endorsement of J. Elmore Martin to be elected. Simply put, you were either a "Martin Man" or you were not elected.

The fourth and newest group to organize and flex its political muscle was the Catholics, led by John Grace. This group was largely composed of the Italian or Irish white working class of the city. In 1910, the Irish accounted for 15 percent of the white population in Charleston. They were feverishly anti–Broad Street, even more than anti-black. They were willing to look the other way on issues of drinking, gambling and prostitution, but were the most committed group to industrial development.

While each political faction within the Democratic Party believed it could best guide Charleston to achieve the grandeur of the past, all were holding court over a crumbling empire. Many of the grand homes that did survive the Great Fire of 1861 and the longest siege of the Civil War were falling to ruin. Many homes and churches that were destroyed lay fallow, bearing an eerie witness to the devastation that had befallen Charleston.

The former aristocratic families could barely hold onto their homes for the taxes that were assessed. The cliché "too poor to paint, too proud to whitewash" was the order of the day. On some of the grandest streets in the city, mansions in decay stood next to similar buildings now reduced to tenements, occupied by as many rats and vermin as poor tenants.

Over half of the city's fifty-eight miles of roads were dirt. Much of what was "paved" was gravel, oyster shell or cobblestones left from another era. There were more than ten thousand privies still operating in the city. The very limited sewer system only serviced homes south of Broad Street. Many of the streets acted as open sewers and drains, leaving Charleston to suffer high rates of disease. Dr. Henry Horlbeck, the city's health officer, reported that the city had "privy vaults polluting our soil, poisoning our cisterns and

Corrupt but Content

East Bay Street in Charleston, circa 1910. This area is later restored and becomes known as "Rainbow Row." *Author's collection.*

Circular Congregational Church on Meeting Street, Charleston. The horse-drawn trolleys were a popular method of downtown travel. *Author's collection.*

wells." These intolerable conditions resulted in a high rate of deaths by typhoid fever, caused by drinking polluted water, and "diarrheal diseases," caused by eating spoiled food and meat.

Charleston had never enjoyed a reputation as a community that eagerly embraced change. The first gas-powered automobile arrived in 1899, brought from Boston by Captain Ernest Patterson. He enjoyed several drives around the Battery before the city banned the device as a "public nuisance." In the next ten years, other automobiles arrived and the city relaxed the ban, though these gas-powered contraptions were still rare and a novelty rather than a necessity. In 1910, an "automobilist" offered to give rides for one dollar to raise funds for an Elks Club charity.

The antiquated condition of the port and railroad facilities caused Charleston to lose business to its sister ports of Savannah and Norfolk. The city hosted the South Carolina Interstate and West Indian Exposition in 1901–02, hoping to attract new industry and revive the economy. Charleston billed itself as the most effective gateway to trade with the West Indies.

Though the six-month event did attract more than 650,000 attendees, the exposition closed on May 31, 1902, posting a financial loss, leaving creditors paid only sixty-five cents on the dollar for goods and services supplied. The exposure for Charleston did ultimately attract a cigar factory, an oyster-canning facility and a fruit importer to relocate to the city.

Following the exposition, eloquent newspaper editorials entitled "Watch Charleston Grow!" and "Long Live Charleston! The City of Dreams" attempted to will the city into prosperity, but the economy continued to languish. While little progress was being made, the country was, at least, taking note of the efforts of the Holy City. The *Brooklyn Standard Union* published an editorial noting:

> *The last and the most firmly entrenched city of somnolence in the whole South has capitulated and decided to take its place with the other progressive centers of the country. That town is Charleston, S.C., which until a comparatively recent date was content to live on in the same old leisurely fashion of the ante-bellum days and ignore the world and deride the march of material progress.*

The reporter got a little carried away in stating that "customs and traditions that forbid progress and were held sacred are in many cases now given only scant consideration." Truthfully, the city's customs and traditions still ruled the day, and the impenetrable social lines were still firmly entrenched.

Corrupt but Content

Even considering the pronounced ills of slavery, the early twentieth century was the worst period of race relations in the history of the port city. In 1910, Charleston, like all of the American South, was in the firm grasp of the Jim Crow era. Jim Crow was the name of a nineteenth-century minstrel caricature of a black man. By the turn of the century, the name became synonymous with laws intended to control Southern blacks. Once "home rule" was reestablished, South Carolina, like other Southern states, began legislating control over the large black population.

The difficult period of segregation was new for Charleston, a city that was one of the most integrated in the country. Charleston, historically, had a large free black society, and this population coexisted with white Charlestonians. Residential wards throughout the city were mixed race, and everything from restaurants to the theatre accommodated black and white citizens.

Now, the new laws were established to provide for segregation on railroads, streetcars, ferries and steamboats. Blacks were not allowed to ride the new electric trolleys in the city. Blacks were not allowed in the same restaurants, hotels, parks or playgrounds. They could not stroll along the famed Battery or sit at White Point Gardens.

Drinking fountains and restrooms were clearly marked with signs declaring "Whites only." Even the beaches were marked for "Whites only." As a conciliatory move, several "Colored" beaches were established, though blacks noted that a section marked on Morris Island was accessible only by boat and the waters were known to be infested by sharks!

The new state constitution of 1895 provided for the payment of a poll tax, property tax and a demonstrated command of the state constitution in order to vote in any election, effectively eliminating the black vote, which made up 53 percent of the total population for the city. By 1903, fewer than 3 percent of Charleston's blacks were registered to vote, and, though an unintended consequence, white voter registration dropped by 50 percent as well.

Blacks were not selected to serve on juries, and some courts even used a separate Bible to swear in black witnesses. There were no black city officials or black police officers.

One early twentieth-century Charleston guidebook for visitors took up the issue of slavery. The text reflected a strong societal view that blacks were inferior and lucky to be "provided for" by the white population.

> *Unfortunately the word slave was given to the African—a word most distasteful to the ears of free men. But the condition of the southern slave was the best of any peasantry in the world. It was the greatest compliment to the southern people's good influence on the race, that in about 100*

years, they had raised it from cruel barbarism to be worthy, in the view of statesmen of 1865, to become voting citizens of a white man's country.

Despite the Thirteenth and Fifteenth Amendments, the state legislature had effectively positioned blacks in a legal category that provided fewer rights than those enjoyed under the system of slavery.

As segregation became the social order of the city, the many blacks living in the lower wards of the city became a concern. A 1910 editorial in the *News and Courier* wrote, "The concentration of negroes in the back alleys and elsewhere in the choice residential districts has been the result of innumerable causes, the poverty following the war, the long years of depression and the great age of the town." Blacks were encouraged, and sometimes forced, to relocate in the upper wards, north of Calhoun Street.

These black sections of the city were referred to as "Jungletown" or "Darktown." In these wards, police presence was high and crime was of immense concern. Many young blacks preferred the lucrative pursuits of gambling, bootlegging, prostitution and selling cocaine to the paltry wages paid to them by white businessmen.

All activities of Charleston's black population were watched and regulated. Any "negro affair" held in the city, such as a dance or party, had to be licensed at city hall and a five-dollar fee paid. This was done both for control and to limit the number of events at which blacks could congregate.

Facilities in town such as Carpenter's Hall, Bricklayer's Hall and Drake's Hall would sometimes pay the fee, obtain a license and host a black dance. There were also a number of clubs for blacks, such as the Tryall Social Club and the Buckeye Social Club. These clubs would advertise their big events in the *News and Courier*, announcing "Darktown Dances" or "Jungletown Jigs" to be held. The Tryall Social Club on Tradd Street boasted an orchestra consisting of three guitars, a mandolin, a banjo and a zoboe.

Public education was low on the list of budget priorities for the city, covering less than 10 percent of the annual budget. Teachers were paid thirty-five dollars per month, leaving only city maintenance workers receiving less pay. Unlike during the Reconstruction period and through the nineteenth century, there were no longer any black teachers in Charleston's public schools. Support for public education waned as Porter Military Academy addressed the needs of Charleston's young men of privilege. Ashley Hall, a private school for girls instituted on the grounds of Confederate Treasurer George Alfred Trenholm's estate, opened in 1909.

All city public education was governed by a board of white commissioners to oversee the three white and two black grammar schools and Memminger

Corrupt but Content

Housing in Jungletown. *Courtesy of the Charleston County Public Library.*

Normal High School for girls. White males attended Charleston High School, which was governed by its own board of trustees.

The prevailing public concern was that anything beyond the basic or vocational education of the black population might serve to undermine the social structure of the city. A March 1910 editorial in the *News and Courier* asserts, "The negro who knows just enough to read all sorts of sentimental literature that makes him believe he is legislated against is a dangerous negro." More than 25 percent of blacks over the age of ten were illiterate.

Despite the crumbling infrastructure of the city, crime was so rampant that it was the number one social issue of the city. Though still inadequate for the demands placed upon it, the police force was the largest department on the city's payroll, and the police chief was the highest paid public official, earning more than $2,000 per year.

Chief Boyle, in his 1910 annual report to the mayor and city council, stated:

> *I feel constrained from a sense of duty to call your attention to the condition of the Police Force, which is numerically and physically absolutely inadequate to meet present demands.*
>
> *Owing to increased business and the building in new territory within the city limits, there has been a corresponding increase of new posts to*

> be filled. Not only is the full strength of the force insufficient to control the situation, but the number of policemen detailed specially to enforce the Dispensary Law has lessened the quota for street duty. The force is further weakened by having men, who from age and long service, have become so physically impaired as to be under the standard required for a policeman. To summarily discharge these men would, not only be heartless, but little less than criminal.

The police were unwilling to confront the abundance of flagrant vice crimes around them due to both the sheer number of the crimes and the public's tolerance for them. Open drinking, gambling and prostitution were all longstanding Charleston traditions. This often caused great tension between Charleston County Sheriff J. Elmore Martin and William Boyle, the city's chief of police. Martin felt strongly that Charleston was a modern-day Gomorrah that needed to be cleaned up.

Chief Boyle and his department focused their energies on the robberies, assaults and murders in the city. The *News and Courier* followed the daily police log with great attention. A Sunday issue in 1910 noted, "Saturday was marked by the usual carnival of cutting, carving, slashing, shooting, banging, knocking, battling and general fighting among the inhabitants of Jungletown." Fighting and stabbings were commonplace in the taverns along Market Street east of King Street.

Both the Charleston police force and the Charleston County Sheriff's Office were profoundly tough on the black citizens of the city. Black Charlestonians gave a wide berth to any approaching police patrolman. Whenever they heard the infamous paddy wagon, the "Black Maria" or "Black Lucy," coming down the street, everyone immediately took flight. Having witnessed too many arrests, blacks knew that if the police couldn't find who they were looking for, they would often arrest who they could catch. No one on the street wanted to risk being placed in the wagon and, later, disappear behind the formidable doors of the City Police Station on St. Phillip Street.

Most assaults and murders in Charleston were black-on-black crimes. Black-on-white assaults were rare and usually occurred when the assailant was high enough on cocaine to ignore the social order of the city. If black-on-white assaults were rare, black-on-white murders were almost unheard of in the early twentieth century.

The murder of a black was often attributed to suicide or death by natural causes to avoid wasting time investigating these events in Jungletown. The court punishments for crimes gave great consideration to the race of the

Corrupt but Content

William A. Boyle, chief of police, City of Charleston. *Courtesy of the Charleston County Public Library.*

This wagon transported the chain gang from St. Andrews Parish to various work details throughout the county. *Author's collection.*

victim of the offense. Those blacks convicted of assaulting whites would serve sentences running for years, and many were assigned to the black chain gangs that had come into vogue in the twentieth century. One black resident of Jungletown was convicted of "assault with intent to kill" a black woman and sentenced to pay a fine of $25 or serve twenty-five days in jail. In the same court session, "James Watson, a Negro," was found guilty of stealing chickens from a white merchant and was fined $100 and sentenced to twelve months on the chain gang.

In Charleston, it was not just blacks who were treated as inferior citizens. White Charleston was stratified as well. Opportunity, privileges and even justice were contingent upon one's place in the social order. One death presented in a coroner's inquest clearly illustrated the advantages of social status and connections. Two men were arguing outside the theatre one evening, when the businessman hit a day laborer over the head with a coconut. After staggering a few steps, the laborer collapsed and died.

The coroner scheduled an inquest, at which a doctor testified that he "failed to detect the slightest cause of death from violence." After deliberation, the jury ruled that the laborer died from "congestion of the brain," and the businessman was released without charge.

Corrupt but Content

Occasionally, vice arrests were made when the public outcry needed to be satisfied with token attention. The newspaper reported these events with the same enthusiasm as it did the capital crimes. In September 1910, the police department received persistent complaints about a large craps game behind Roper Hospital. Finally, the department dispatched three patrolmen to the area to break up the game and arrest the players.

Upon arrival, the policeman, accompanied by a reporter, found a large crowd of blacks involved in a most spirited game. As the police blew their whistles and waded in with their billy clubs, the reporter observed, "Thirty negroes, ranging in size from pickaninnies to men, and of all hues and conditions of life, arose from the vacant lot like a drove of blackbirds and soared away."

The three officers gave chase, two on foot and one on a commandeered bicycle. The "sportsmen" fled down Calhoun Street to the Ashley River, creating such a scene that hundreds of spectators, in everything from automobiles and buggies to bicycles, followed the spectacle down lower Calhoun Street. Now cornered, the blacks fled to the marsh along the Ashley River. Not wanting to give chase into the water, the paper reported that Private Brown, to the delight of the large crowd, "threw rocks at any target that presented itself, but could not flush them from the marsh." As dusk approached, the crowd had dispersed and the three policemen, feeling their duty done, retired to the police station for the day.

Drug use was also a major issue in early twentieth-century Charleston. Cocaine was used as an ingredient in many legitimate concoctions and remedies mixed by pharmacists. However, a large amount of cocaine also found its way to the streets. Cocaine, or "Happy Dust" as it was commonly referred to, was a social problem that knew no boundary of race or societal stature, though the newspaper editorials publicly made an issue of the effects within the black community and largely ignored the effects of cocaine on the white community.

In a February 1910 article, the headline announced, "Cocaine Has Grasp on City." An editorial later in the year stated, "The use of this terrible drug [cocaine] is growing here and it is doing more than any other single agent to demoralize the Negro population. It impairs the efficiency of their labor to an extent which is scarcely believable. It crazes them and leads to innumerable brawls."

In a July 1910 article titled, "Cocaine Evil Spreading," physicians interviewed by the *News and Courier* estimated that "one negro in every four [was] said to use the drug." The reporter continued, writing, "The users of the drug claim that a dose gives them 'courage,' 'sweet dreams,' and a sort of exuberance of spirit."

Charleston's Trial

As much as polite society would have liked to believe it, use of Happy Dust was not restricted to the blacks of the city. In July 1910, a white woman crazed on cocaine caused quite a disturbance on Market Street. Responding to a call, police officers arrived at Market Street and approached a woman in an agitated state. As they neared, she withdrew a pistol concealed under her dress and fired at the officers. A chase and gun battle ensued through much of Market Street. After ducking down an alley, the panicked shooter took shelter in a privy behind one residence, firing a shot through the door. The police officers opened fire on the privy, killing the woman.

In a separate incident, Private Philip Shokes was patrolling Market and Church Streets late one morning. Shokes heard loud cursing in a "negro restaurant." Entering the restaurant, Shokes found a white woman, Sadie Miller, in a loud argument with a black woman. He escorted Miller out of the diner to quiet her down.

Once outside, Miller ducked into Mr. G. Scragalos's Greek eatery on Market Street. She grabbed a butcher's knife, declaring her intent to find the black woman in the other restaurant. Patrons wrestled the knife away from Miller, but as she saw Shokes coming in to, once again, restrain her, she grabbed a gun from behind the owner's counter and fired through the glass door at the policeman. Shokes returned fire and raced inside, while Miller fired twice more, missing once and grazing Shokes's head with the second shot.

Miller continued out the back door of the restaurant and fired again, but missed. Shokes, in pursuit, fired twice, hitting her in the abdomen and left breast. Miller cried out, "Send for the wagon." Thinking that his suspect was incapacitated, the officer cautiously approached. Suddenly, though prone in a pool of blood, Miller pulled the trigger once more. The gun misfired and miraculously Shokes was spared. Kicking the gun away, the fortunate policeman arrested his assailant. Unfortunately, such incidents were not uncommon.

With the cocaine abuse came all manner of petty larcenies and break-ins. Herman Hummel opened his Charleston pharmacy one morning to find he had been burglarized overnight. The thief left him a note, writing, "Dear Sir, Have only taken small change. Please have some more handy for me. Will come back soon."

Charleston has enjoyed a long love affair with open drinking, gambling and prostitution, perhaps no surprise for a port city. In 1893, Governor Tillman initiated the state dispensary system, a state-owned and controlled system for the packaging and distribution of alcohol. To enforce this wholly unpopular package of legislation, the Dispensary Act created the state constabulary.

Corrupt but Content

This new force of constables worked in the state where needed in order to address reported violations.

Charleston simply ignored the law, and soon more than three hundred "blind tigers," or illegally operating bars, were established throughout the city. One of the biggest bootleggers in the city was a member of city council. More than one public official was defeated in a bid for reelection as an effective punishment for trying to control illegal drinking. Even though the Dispensary Act was repealed in 1907, bootlegging liquor was firmly entrenched in Charleston and continued through the period of federal Prohibition.

The blind tigers openly served untaxed liquor and offered card games, dice games and slot machines to their patrons. Along with the bordellos, it was worth paying the occasional fine to have the policemen turn their heads and ignore the indiscretions. When the police needed to heed the complaints of the "decent people" in the city and conduct an occasional raid, the tavern was warned so the slot machines and most of the liquor could be removed. The token amount of liquor left was, of course, confiscated in the raid, but it was later sold back to the tavern owner out the back door of the police station. Everyone was happy—the "decent people" had their raid, the police made an arrest, the city coffers enjoyed the benefit of the paid fines and the police officers made something when the liquor was sold back. The tavern was back in operation before some patrons reached the bottom of their glass.

Horse-drawn trolleys were Charleston's version of mass transit. *Courtesy of Danny Peterson.*

Charleston's Trial

In 1910, a frustrated Judge Robert Aldrich declared that the blind tigers and the gambling in the city persisted because police chief "Boyle [would] not enforce the laws." Appealing to the state for help, the governor authorized a task force of constables from Camden, Dorchester, Greenville, Sumter and Cheraw to raid a Charleston tavern. The raid resulted in the seizure of 1,200 bottles of beer, 130 quarts of whiskey, 320 half pints of whiskey, 4 one-gallon demijohns of moonshine and 15 quarts of fine wine—all bootlegged liquor. Though a significant seizure, the Charleston community didn't miss a beat at continuing business as usual, knowing the state had neither the resources nor the appetite to keep up this kind of enforcement.

This open and bawdy behavior in Charleston was viewed with great disdain in the rest of the state. While writing of the ills of Charleston, a 1910 editorial in *The State* newspaper in Columbia summed it all up effectively when it titled an editorial *Charleston—Corrupt but Content.*

CHAPTER 3
AN ISRAELITE LAYS DEAD

Tuesday, June 21, 1910

The day began much like any other for Max Lubelsky, a thirty-five-year-old Jewish tailor and clothier in the Little Jerusalem section of Charleston. He arose early in his apartment located above his clothing store at 543 King Street. As he prepared his breakfast, his thoughts drifted to his wife and son, who were in New York visiting relatives. Though life was much easier with Rose at his side, he had plenty to do operating the store as its owner and sole employee.

He made his way down the back stairs and paused to feed his chickens and pigeons. He entered the store through the back door and turned on the lights, making his way to the front. As he eased through the crowded shop, he straightened stacks of pants and shirts as he went.

Max grabbed the straw broom from behind his sales counter and unlocked the front door. As he opened the door to King Street, the fresh sunshine illuminated the dark interior, but it also showed a dirty floor. King Street, the retail center of the city, was still trying to awaken from its slumber as the trolley passed with few passengers for this time of day.

As Lubelsky swept onto the sidewalk, he heard the swish of Charles Karesh's broom outside the shoe store next door as he, too, was readying for shoppers. Across the street, Mrs. Dora Birlant went through her inventory, peering out at the two merchants. To her, they seemed like two pawns in a vaudeville routine, sweeping almost in unison this way and that. Pulling open the doors to her millinery shop, Mrs. Birlant could see the two men engaged in their morning arguments over the orthodoxy of their synagogue.

Max Lubelsky, circa 1910. *Courtesy of the Lubelsky family.*

An Israelite Lays Dead

Rose Lubelsky with her son Joseph, circa 1910. *Courtesy of the Lubelsky family.*

Lubelsky set his broom inside the shop and pulled the doors shut. Adjusting his hat on his small head, he turned up King Street to make his daily deposit. Karesh had retired to his own store, tucking a shoehorn into his pants pocket, ready for the first customer.

Karesh was a fifty-one-year-old shoemaker. Like many of his countrymen, he had come to America from Russia. He too lived above his store at 545 King Street with his wife and six children.

Lubelsky stepped into the South Carolina Loan and Trust Company, ten doors up the street, and deposited $200 in proceeds from shop sales. As he walked back to his shop, Max passed other shop owners, most of them Israelites like himself. As he neared his own shop, he was met with delightful aromas wafting from the Ostendorff Bakery across the street and Kosta Kitsoo's confectionery next door.

Max had found his way to America from Eastern Europe. Like millions of Jews in the early twentieth century, he left his homeland to avoid persecution and immigrated to America, landing at New York. He had the advantage of knowing a valuable trade as a clothier and tailor, skills that would earn a good living for his family.

While settling in New York, Max met Rose Surasky, who would in time become his wife. Rose had arrived at Ellis Island with her family from Vienna, Austria. They married, and the union bore a son, Joseph. After the turn of the twentieth century, New York was a crowded city with limited prospects as it became overfilled with immigrants, so Max, Rose and Joseph headed south.

Max, Rose and their newborn son arrived in Charleston in 1902, where Max initially worked as a peddler until he opened his tailor shop on King Street.

Many other immigrants had settled in the Southern cities of Charleston, Savannah and New Orleans. Despite a slow economic recovery from the Civil War, all three were still busy ports and had convenient railroad service. The railways were the interstates connecting the Northern states with points south.

Charleston had an early Jewish population and, until surpassed by New York in 1830, the largest Jewish population in the United States. By 1860, New Orleans surpassed Charleston in numbers as well.

The assassination of Russian Czar Alexander II in 1881 cleared the way for the persecution of Jews in Eastern Europe. Referred to generically as "Russian Jews," over the next forty years 2.5 million Jews from Poland, Lithuania, the Ukraine, Romania and Russia fled Europe and set sail for the United States.

An Israelite Lays Dead

Charleston's reputation for religious tolerance, its temperate climate and the longstanding Jewish community here made the city an attractive destination for many of these Jewish refugees. Not everyone, however, made it to Charleston so intentionally. One Jewish immigrant made his way to Penn Station after landing in New York to find a new home by train. He asked the station manager for a recommendation of where he should travel. The manager asked how much money he had, helped him count it and then stated that that sum could get him to Charleston, South Carolina.

By the turn of the twentieth century, Charleston's Jewish population was growing quickly, and by 1907 it had tripled to more than twenty-five hundred. It would double again by 1920. Upon reaching South Carolina, one immigrant, Hiram Surasky, wrote to his wife back in Druzekonick:

> *You can no more compare day and night. No matter what street you travel on here there are parks and alleys full of delightful aromas. It is a place like you could only dream about in Europe. Only the imagination could dream of it. When you come to this place you will not have to be lonely. You won't have to worry about a scarcity of money and here every one will try to please you.*

These new arrivals in Charleston were much different from most of the city's older Jewish families. They were generally not wealthy people coming from a much different culture and different customs than Charleston Jews. They were not comfortable with the reform ways of the Kahal Kadosh Beth Elohim synagogue, preferring the traditional ways of the B'rith Shalom congregation.

Many of these new Jewish residents started as peddlers. Others with more resources established retail stores, selling clothing, notions, furniture or shoes along upper King Street, opening their shops on the street level and living above. With the establishment of these shops, and with others choosing to live in the wards north of Calhoun Street and west of King Street, this area of town became known as "Little Jerusalem." On some streets, it was impossible to distinguish between Little Jerusalem and Darktown, with both groups being pushed to similar sections of the city.

These shops in Little Jerusalem flourished, catering to blacks and blue-collar whites. Unlike the white department stores, the Jewish merchants would allow black customers to try on hats, clothing and shoes before purchasing them. They also routinely extended easily obtained credit to their neighbors in Darktown.

This Yiddish-speaking, Eastern European merchant class, however, in time found that even the traditional B'rith Shalom was not orthodox

Charleston's Trial

The shopping district on King Street. "Little Jerusalem" was located north of Calhoun Street. *Courtesy of Danny Peterson.*

enough for them. Fanning the flames of discontent, in 1910, for the first time ever, the president of the congregation decided to keep his shop open on Saturdays. This launched an intense, sometimes violent confrontation within the congregation and was the catalyst for a large group of newer residents breaking off to form another synagogue, Beth Israel.

Unaffected by events at the synagogue, Max Posner, a local peddler, arrived at Lubelsky's store just before twelve noon. Posner brought his young daughter to the store, hoping to show her the chickens and pigeons he had sold to his good friend several weeks before.

Upon entering the store, Posner called for Lubelsky, but got no reply. Thinking his good friend may be out back tending to his birds, Posner walked all the way through the store. Still not finding the tailor in the rear yard, he called up to Lubelsky's apartment, but received no response.

Posner reentered the store, still calling for his friend. He placed his daughter atop a stool in the middle of the store and leaned across a counter to wait for his friend's return. It was not like Lubelsky to leave the shop open, even if he was only visiting the other nearby Jewish merchants.

While passing time stretched across the counter used for folding clothes, Posner observed a dark, wet puddle under the display table. Even with the lights up, Lubelsky's store was dim in many places, especially around and

under the long tables that held his goods.

Posner slid off the counter and crouched down, placing his finger in the puddle. As he did, a hand appeared from under the counter, twitching first and then falling limp. Posner knew now that his fingers were covered with blood, Max Lubelsky's blood. Falling to both knees, Posner reached for his friend, trying to lift and pull at the same time. His daughter, struck with the horror of it all, had jumped off the stool, landing almost directly on Posner's back as he tried to render aid.

Lubelsky moaned, moved his head to one side and then fell quiet. The young girl let out a shriek at the sight of the poor little man, stuffed under the table, with blood pouring from his head.

Feeling helpless, but knowing that he needed to move quickly, Posner grabbed his daughter and raced next door to Karesh's shoe store. Karesh was seated inside his store in a chair by the window. Posner raced into the quiet shop, flailing his arms in the air, yelling that Lubelsky was hurt badly.

Karesh refused to leave his store with no one to watch over his stock. Exasperated, Posner stood on the street, calling for help. As he turned south, he could see a policeman standing in front of Duffy Brothers Jewelry Store. Posner screamed until he had the attention of the officer. As Sergeant Stender approached, it was hard to decipher what the excited peddler was saying, but it was clear that there was a problem at Lubelsky's store.

Stender arrived and inspected Lubelsky's condition, immediately calling for a doctor. Detective Clarence Levy was riding the trolley down King Street and noticed a large crowd gathering. He jumped off the trolley car to discern the reason for the crowd and was told of the attack. Even flashing his badge, Levy found it difficult to make his way through the crowd. He entered the store to find Sergeant Stender already on the scene.

Levy was fifty-one years old, and he was one of the most experienced men on the force. In 1876, he rode with Hampton's Red Shirts. In Charleston, he was a member of the Aetna Fire Company. After joining the police department, his first assignment was as fire watcher in the steeple of St. Michael's Church at Meeting and Broad Streets. Later, he was transferred to other jobs, including waterfront patrol.

Levy was no stranger to violence, though more often in Darktown than not. Once, when pursuing a black suspect in Cromwell Alley, the suspect turned and shot Levy in the hip. Levy fell on the sidewalk as the gunman approached for a closer shot. Levy drew his revolver from his shoulder holster and shot the trigger finger right off the suspect. Levy then took the man into custody. He walked his assailant right to the nearby jail on Magazine Street, as a trail of blood from both men followed them to the front entrance.

Charleston's Trial

Detective Clarence Levy, City of Charleston Police Department. *Courtesy of Jean Thomas.*

An Israelite Lays Dead

The many Jews on the street were in shock over the attack. The crowd, growing in size and anxiety by the minute, had King Street effectively blocked. The rumors swept around the street like waves crashing on a storm tide, stunning everyone who heard any version of the news.

Word of the brash daytime attack first came into police headquarters from a King Street call box. Within minutes, the station was busy as officers and detectives headed for the scene. The desk sergeant stepped down from his platform and walked out the front door, looking up and down St. Phillip Street as people ran back and forth, animated by the tragedy.

Dr. Kevy Pearlstine arrived and examined Lubelsky, insisting that he be sent to the hospital for treatment. In looking for Lubelsky's wounds, the young doctor found a number of deep gashes on his head.

Pearlstine was a young doctor just starting his medical practice. He was then single and living with his sister and brother-in-law, Louis Jacobs, on Rutledge Avenue.

Most murders occurred in Darktown, and even then at night, fueled by booze or Happy Dust, or both. This, however, had happened on King Street in the middle of the morning. Even as the ambulance wagon sped away, most of the merchants in Little Jerusalem were in some combination of shock and denial.

The injured tailor was transported to Riverside Infirmary, next to Roper Hospital. Dr. Pearlstine shaved Lubelsky's head to allow for a thorough inspection of the injuries. He found large lacerations in his scalp, one on the back of the head, one on the right and a third on the top. Lubelsky never regained consciousness. He died within thirty minutes of his arrival. When Pearlstine conducted the postmortem examination of the body, he found approximately six skull fractures and a hemorrhage of the brain. It was clear that the tailor had been beaten viciously and repeatedly with great force.

Back at the clothier's shop, Sergeant Stender and Detective Levy were joined by Patrolman Schultz and Officer Fultz. Schultz and Fultz kept the excited crowd at bay. Word had now reached the store that they were no longer investigating an assault—this was now a murder scene. Levy was joined in the investigation by Detective John Brennan, Chief of Detectives James Hogan and Officer John Hogan.

Upon inspection, police found Lubelsky's store in disarray, with overturned piles of clothes at the rear. The cash drawer near the front of the store had been pulled out, and there was no money left in the till. Checks and some coins were scattered about the floor. Near the center of the store, a hot pressing iron, a crowbar and a hatchet were found. A show window on the storefront appeared to have been forced open, leading police to believe that

a suit of clothes may have been removed. The store had every appearance of someone rifling through in a hurried manner.

Levy and James Hogan marked the location of the body, observing that the floor was "literally soaked with blood," which had also bespattered the walls and fixtures nearby. One of the counters was covered in bloody fingerprints, as if Lubelsky had tried to raise himself after the attack. The condition of the shop suggested to the detectives that the physical confrontation between Lubelsky and his killer was limited to where the body was found.

Based on the evidence, the police theorized that someone, seeing Lubelsky pressing clothes in the shop, crept behind the tailor, hit him and robbed the store of cash and clothes. Detectives surmised that the attack to subdue Lubelsky must have been quick since the affair was not noticed by anyone passing on the street, nor was it overheard by the neighboring shopkeepers.

While detectives were investigating the murder scene, they canvassed the neighboring stores and found no one who was aware of a disturbance. Charles Karesh, Lubelsky's next-door neighbor, did offer information about a black man, carrying a stick, who had been loitering around his store that morning between 10:00 a.m. and 11:00 a.m. Uneasy with the man's continued presence, Karesh indicated that he spoke to the man, but received no response.

As news of the murder swept across the city, Frank Frost, a black drayman, arrived at the Lubelsky store to offer information to the detectives. He indicated that he was at the store at 11:15 a.m., attempting to deliver a package of goods to Lubelsky. He was met at the door by a black man who professed to be Lubelsky's porter, asserting that he was watching the store while the owner stepped out to visit a nearby shop. After waiting for a few minutes, Frost told the "porter" he would return later.

Based on the observations by Karesh and Frost, the police immediately released a description of the suspect. The murderer was believed to be a black man of about twenty-five to thirty years of age, with a light complexion (perhaps mulatto), who was clean shaven and about five feet, six inches tall.

Policemen were dispatched to search all outgoing trains, and roadblocks were established at the major streets leading from the city. An official announcement of the murder and a description of the suspect was wired to outlying towns. Finally, Police Chief Boyle had the ominous task of telegramming Mrs. Lubelsky in New York that her husband had been murdered.

Boyle, seventy-one years old, was one of the few actual war heroes still alive in the "City of Secession." The son of a cotton planter and born to a life of privilege, Boyle enlisted as a member of the Palmetto Guards at the outset of the war and was appointed to the rank of sergeant. He was

An Israelite Lays Dead

Police were dispatched to Union Station, Charleston's train station, looking for anyone fitting the description provided by Karesh and Frost. *Author's collection.*

accepted in the Charleston Light Dragoons and quickly worked his way up the ranks to major. As a member of this elite cavalry unit, Boyle served on Wade Hampton's staff until the end of the war and was with Robert E. Lee and Hampton at Appomattox.

After being paroled in Virginia, Boyle returned to South Carolina, where he worked as a cotton planter and factor in Summerville. With sufficient labor difficult to find, and fighting with hurricanes and low market prices, he resigned himself to the obvious fact that cotton would not usher a return to the wealth and luxury of the glory years before the war. Boyle secured a position as an agent for the railroad at the close of the nineteenth century, a job he held until the Broad Street Ring and Mayor Goodwyn Rhett tapped him to be chief of police in 1908.

Before the day was over, good news arrived by wire. The police in Bamberg were detaining a black man named William Murray, who fit the description published by the Charleston police. Murray was taken from a Charleston freight train as it arrived in Bamberg. Chief Boyle appeared before Magistrate Williams, obtained a warrant for Murray's arrest and sent Detective Brennan to return him to Charleston.

CHAPTER 4
Searching from Uptown to Darktown

Wednesday, June 22, 1910

The "third degree" was the name for a series of interrogation techniques used by police to obtain information from uncooperative suspects. In an interview with the *News and Courier*, Detective Hogan once described some of the specific techniques employed. First, the suspects were subjected to a long series of rapid-fire questions shouted by detectives and policemen in a seemingly endless relay. Next, suspects were denied sleep for up to three days by use of "various devices," which the detective would not disclose.

Along with sleep deprivation, the suspects were also denied food and water for extended periods. When finally fed, the suspects were given highly salted food, but still water was withheld. Additionally, the Charleston police made use of a sweatbox for particularly difficult prisoners. Hogan did not offer any information about the slapjack used on the most difficult of prisoners. The intent of the "third degree" was to break down the suspect, causing him or her to seek relief by confessing.

On Wednesday, Brennan returned to Charleston at 8:15 a.m. with his prisoner from Bamberg. With Murray in tow, Brennan checked in with the desk sergeant and proceeded up the imposing staircase to the second floor. There they were met by an older man who wore the strain of years of criminal investigation across his face. A fancy mustache and goatee worked to soften Detective Levy's countenance, but it did nothing to temper his voice. Soon the interrogation began.

Before joining the others, Chief of Detectives Hogan went to his desk and pulled out a little "persuasion." Only in the worst cases would the suspect need a rap on the knuckles or across the cheeks. This little slapjack, with its

CHARLESTON'S TRIAL

City of Charleston Police Station, St. Philip Street, circa 1910. *Courtesy of the South Carolina Historical Society.*

A Charleston policeman walking a beat at White Point Gardens, circa 1909. *Courtesy of Danny Peterson.*

Searching from Uptown to Darktown

leather-covered metal head and spring-loaded grip, was designed for rough play and delivered a heavy blow.

While the interrogation of Murray continued through the day, the coroner's inquest was held at 11:00 a.m. at the parlors of the J. Henry Stuhr Funeral Home on Wentworth Street. The inquest jury heard testimony from five witnesses, including Detective Levy, Sergeant Stender, the peddler Max Posner, Frank Frost and Charles Karesh. The inquest proceeded despite the fact that Mrs. Lubelsky had not yet returned by rail from New York.

Levy testified first, describing the crime scene and the early investigation. Stender described being summoned to the scene by Posner and finding Lubelsky lying unconscious in a pool of blood in the shop. Like Levy, he also described the crime scene and the appearance of what seemed to be a robbery.

Posner testified to finding Lubelsky initially, though he offered nothing to suggest evidence of a robbery. Karesh and Frost described their encounters with a black man at the store early on the morning of the murder.

The jury concluded the proceedings announcing "the said Max Lubelsky came to his death at Roper Hospital, Charleston County, from wounds inflicted with a stick, or door bar, in the hand or hands of party or parties to the jury unknown, at No. 543 King Street, Charleston County."

At the police station, Murray insisted he was attending a "colored picnic" at Remley's Point on Tuesday, the day of the murder, and gave the names of several others in attendance to speak for him. However, when police interviewed others at the picnic, they confirmed Murray's presence in the afternoon, but not in the morning. This turn of events was disturbing to the police, as Lubelsky was killed before noon.

Murray stated that he left town on Tuesday to visit friends in Augusta and jumped a freight train to make the trip. At Branchville, Murray left the freight train and climbed on the roof of a passenger coach of a Southern Railway train for the trip to Georgia. His method of travel suggested that he had no funds for a ticket, but more importantly, police surmised, he wanted to travel unseen. However, upon reaching Bamberg, he was spotted on top of the train and arrested.

Murray did possess a striped handkerchief identical to some found in Lubelsky's stock; however, detectives determined the same handkerchief was for sale in several uptown shops as well.

Rose Lubelsky and her son arrived in Charleston by train at 8:00 p.m. Wednesday night. In support of the family, friends of Max Lubelsky had raised $600 to offer as a reward for anyone finding the killer.

CHARLESTON'S TRIAL

Thursday, June 23, 1910

The police resolved that Murray was not the killer and aggressively pursued additional leads, arresting seven other black men as well. The *News and Courier* reported:

> *The "third degree" has been applied in each case but without avail, as the prisoners were able to establish complete alibis, or in other ways proved they were not connected with the murder. The police dragnet has been working day and night during the last seventy-two hours and every nook and hiding place in and out of Darktown has been thoroughly searched and gone over a dozen times.*

Given the solid descriptions provided by Frost and Karesh, the lead paragraph in the *News and Courier* article was confounding. It read: "Who killed Max Lubelsky last Tuesday morning? Was it a white or colored person who committed the foul deed? These are the two questions which the Charleston Police have been asking themselves continuously during the last three days." The article ended on an equally provocative note, reporting, "Chief of Police Boyle and several detectives hinted last night that they formed entirely new theories regarding the killing, but refused to give out these views for publication." As public pressure to solve the case was escalating, it was clear that the Charleston Police Department was at wit's end over finding the killer.

As the case was seemingly not moving forward, and the police were questioning the very theories of the murder, Max Lubelsky was buried on June 23 in the B'rith Shalom cemetery at "3 Mile House." On the same day as the funeral, Mayor R. Goodwyn Rhett announced that the City of Charleston would offer a $150 reward for the capture of Lubelsky's killer. This now brought the reward total to $750, with the State of South Carolina expected to contribute to this fund as well.

Friday, June 24, 1910

By Friday, it was clear that William Murray, though still confined, would not be connected to the murder case. He was transferred to the county jail on a warrant charging him with disorderly conduct and assault on a previous trip, during which he jumped a Southern Railway train and, when confronted by two railroad officials, attacked them both.

Searching from Uptown to Darktown

City of Charleston Police Department staff picture, circa 1912. *Author's collection.*

Two new black suspects were arrested, but neither was identified by Karesh or Frost as the man they saw at the shop on Tuesday.

On Monday, June 27, Detective Brennan arrested another black man, Henry James, on suspicion of his involvement with the murder. Given the "third degree," James did not break and confess, but he could not give a satisfactory account of his whereabouts on June 21, the day of the murder. Providing further interest in James as a suspect, Karesh was brought in to the station for identification and was unsure if he was the man in front of the store. This offered at least some encouragement to the police, whose interest in James continued, as Karesh had been quick to rule out previous suspects. By day's end, police would not call James an official suspect, but they did indicate that he would be held for further examination.

On Saturday night, July 2, an unfamiliar black man arrived in Holly Hill, fifty-two miles west of Charleston. The Holly Hill police noted his suspicious nature and his resemblance to the description published by the Charleston Police Department. After conferring with Charleston police, Holly Hill Chief of Police J.O. Bunch had the suspect arrested on Tuesday.

Charleston's Trial

Though police thought it to be an alias, the prisoner gave his name as Willie Zipps. Zipps had a newspaper clipping about Lubelsky's murder in his pocket when he was picked up in Holly Hill. Chief Bunch notified Charleston Chief Boyle of the arrest, and Detective Levy was sent to return the prisoner to Charleston.

On Wednesday, June 29, Karesh and Frost were brought in to the station, a place now becoming familiar to them, but neither identified Zipps as the suspect. Furthermore, Zipps provided police with information about a job he held on June 21, and his employer came by the station to verify his story, providing Zipps an effective alibi. With no new leads to pursue Zipps, he was released from custody.

Again, on Wednesday, Karesh indicated that while he was not positive James was the man he saw in front of the store on June 21, he could not rule him out. This at least bolstered hopes in the police department and the Jewish community that something could develop connecting James to the murder.

Over the next seven days, the case began to slip from the news, with no new developments to feed the interest of the newspapers. The murder and lingering investigation began to disappear in the street conversations as friends and acquaintances convened. James continued to be held, "pending further investigation." Suddenly, on July 6, another black man answering the description was picked up in Charleston by police. This new suspect, Anthony Jour, like James, could not satisfactorily account for his whereabouts on June 21. The investigation of Jour was slowed as Karesh was out of town in New York and was not available to attempt identification.

Ready to close the books on this tragic case, the police tried to assure themselves that those responsible for the murder of Max Lubelsky now rested within the confines of the jail. Both men fit the description, neither had an alibi and, at least in the case of James, Karesh could not rule out the possibility that he was the culprit. Everyone was now anxious for Karesh's return to town to view and pass judgment on Jour. Whether the responsibility for the murder rested with one, the other or both, the police were only too happy to hold credible suspects in custody.

CHAPTER 5
A Costly Stroll in the Morning Sun

Friday, July 8, 1910

Uptown King Street was shocked when, midday Friday, just two weeks after the murder of Max Lubelsky, his widow, Rose, appeared at the door of the shop, screaming, with blood streaming down her face. The scene unnerved the people who happened to be on King Street as she emerged from the shop. The Saturday article in the *News and Courier* accurately captured the mood, stating:

> *Upper King Street was stirred deeply yesterday, when the news spread like wild fire that a second dastardly assault had been perpetrated in the Lubelsky store, the victim of the outrage being Rose Lubelsky, widow of Max Lubelsky, the tailor, who was foully murdered in his store at No. 543 King Street, at midday on Tuesday, June 21.*

Isaac Goldman and Moses Needle were standing in the clothing store of Jacob Needle, across the street and several doors south on King Street, when they heard the screams. Running to the street, they witnessed a black man walking down King Street. Assuming the black man was the perpetrator, they chased after him, noting that he did not run until they were upon him. Goldman and Needle would later report that the black man ducked into the Chinese laundry operated by Chu Tie, five doors south of the Lubelsky store. They grabbed the suspect and pulled him to the street.

By this point, a large crowd had gathered, astonished that, with everything Mrs. Lubelsky had faced; now she had been attacked. In just minutes, several other men grabbed the black man, and the angry mob turned to thoughts of immediately lynching him on the street.

Charleston's Trial

Police officer W.H. Stanley was walking his regular beat at the corner of King and Anne Streets. First hearing the commotion, he looked up King Street to find a large crowd covering the sidewalks and width of the street. Stanley ran to the crowd and, seeing the black man forcibly held, rushed to place him under arrest, if for no other reason than to prevent a violent mob response to what was obviously a volatile situation.

The black man offered no resistance, but he did reach into his pocket, drawing a response from Stanley's club, rapping him on the hand. A police patrol wagon arrived, and the black man was placed inside. Before he could be spirited away, one man in the crowd reached inside with his fist, hitting the prisoner in the back of the head. This vigilante was reprimanded by police as the patrol wagon sped away. The suspect was sent to the police station, where he was interviewed personally by Chief Boyle.

Rose Lubelsky told the reporter for the *News and Courier* that she was serving a black customer in the store. He purchased eight dollars of goods, and as she wrapped the purchase and extended her hand for the payment, she stated, "I saw him raise his hand about so high (indicating a position above her head) and I thought he was raising his hand mighty high—then I don't know anything more." She indicated that he hit her on the head with an object, and she then turned and ran for the street, screaming for help.

Once the prisoner reached the police station, he identified himself as Daniel Duncan. Chief Boyle had several officers return to the Lubelsky store and home to allow Mrs. Lubelsky to identify her attacker. Dr. Pearlstine was at the Lubelsky home dressing the victim's wounds. To avoid causing a stir on the street, the patrol wagon holding Duncan came through an alley to the back of the store. Once her medical attention was complete, Rose Lubelsky was escorted downstairs by friends to confront her attacker. Several armed officers presented Duncan in shackles, and she identified the young black man as her assailant. Having obtained the desired result, Duncan was quickly escorted back to the station.

Detectives in the Lubelsky store found three pieces of wood near the counter where the widow was attacked. One, a two-foot-long piece of split pine stove wood, was determined to be the weapon used in the assault. Dr. Pearlstine explained to the investigating officers that Mrs. Lubelsky had been hit once, causing a laceration on her scalp, but it was not serious. Pearlstine theorized that her thick hair may have saved her from more serious injury.

The very accusation that Duncan had attacked Rose Lubelsky caused the police to believe that he was also responsible for the heinous attack and murder of her husband. As with the previous black men brought to the station, the "third degree" was applied to Duncan, but this intense interrogation bore no

A Costly Stroll in the Morning Sun

fruit for the police. Much to the surprise of the investigating officers, Duncan maintained a calm demeanor throughout his arrest and interrogation, and he vehemently pronounced his innocence. In searching the prisoner, the only thing in his pants pocket were copies of an invitation to his own wedding, scheduled for July 13, just five days later.

Duncan insisted that he was carrying his hat with his coat over his arm, walking down King Street, as was his habit at midday when he got off work. He asserted that when he heard the lady screaming, he simply turned in that direction and walked toward the commotion and the crowd that instantly gathered. He added that as he stood in the street by the trolley car track, two men grabbed him and, later, hit him. Duncan told of being accosted by the angry crowd—someone even called for a rope—until the policeman arrived and arrested him.

While the interrogation did not yield anything to incriminate him, the police did gain a detailed understanding of the background of the accused. His full name was Daniel Cornelius Duncan, known to his friends as "Nealy." He was twenty-two years old and had been born in Charleston. He lived in a crowded tenement with his father, brother, several sisters and others at 48 Vanderhorst Street, just minutes away from the Lubelsky store. Duncan's residence was also just around the corner from the station where he now sat.

The other readily apparent feature of Duncan was his stutter. While he appeared intelligent in answering the rapid-fire questions presented, he did exhibit a severe speech impediment, which made listening to him both difficult and tiresome.

Duncan worked as a baker at Geilfuss Bakery near Calhoun and Anson Streets, where he had been employed since the age of nine. Rudolph Geilfuss, a native of Germany, came to America when his family moved to Charleston, and his father opened the family owned bakery. The bakery was known for its fine breads, pies and cakes. The special was "A.G. Bread," in great demand in Charleston. The successful shop sold its wares wholesale and retail through the store and kept two wagons busy delivering throughout Charleston.

After the death of Duncan's mother, Rudolph Geilfuss became somewhat of a surrogate parent, not only providing employment, but also providing the poor, likable boy with at least two meals a day. As Duncan grew older and took on more responsibility, Geilfuss taught the boy to be a baker and ensured that he learned to read and write. Baker's hours were, of course, unusual, requiring work through the night so the baked goods would be ready for purchase first thing each morning. As such, Duncan reported for

work at 8:00 p.m. and worked through to sometime between 10:30 a.m. and noon, depending upon the chores to complete.

Duncan was engaged to be married, as the invitation also stated, on July 13. His fiancé was a sixteen-year-old black girl, Ida Lampkin, who lived in town at number 4 Palmetto Street with her mother, Mrs. Mary Lampkin, and younger siblings, a sister Ella and brother Indie.

Chief Boyle dispatched Detectives Levy and Hogan to Duncan's residence to look for evidence to tie him to the June 21 murder. At the tenement, the detectives confiscated a quantity of clothing and a box of jewelry found under a bed pillow. They also found a stiff hat in the tenement and confiscated it as well.

While conducting their search, Levy and Hogan encountered Buchanan Duncan, their prisoner's father, and Samuel Peeples, a friend of the accused who lived at the same tenement. Given the clothing and jewelry, which they believed to have been taken from the Lubelsky store, both men were taken into custody and transported to the police station on suspicion of possession of stolen goods. The clothing seized was taken not only from Duncan's room, but also the room of a sister and another unrelated resident.

Chief Boyle had the confiscated clothing inspected by a Jewish merchant, J. Bluestein, who operated a clothing store on King Street. He confirmed for the police that the clothing seized was consistent with the clothing stocked in the Lubelsky store. He felt at least one suit was identical to a suit seen previously in a display window at Lubelsky's.

After a full day chasing leads, Boyle felt that he had enough evidence, albeit all circumstantial, to charge the prisoner with both crimes. Duncan was transferred from the station to the county jail and booked on two charges, "Aggravated assault, striking Mrs. Lubelsky on the head with a stick in her store at No. 543 King Street, Friday morning, July 8 and murder and robbery of Max Lubelsky, at No. 543 King Street, on Tuesday, June 21." Buchanan Duncan, the father who worked as a stableman at the Charleston Transportation Company, was released, as the police were confident that he had no knowledge of the criminal activities of his son. However, Peeples was booked on charges of possession of stolen goods.

Daniel Duncan and Samuel Peeples were picked up after an overnight stay at the Charleston County Jail to appear at the preliminary hearing before Magistrate L.E. Williams on Saturday, July 9. Though the city police preferred the charges, the prisoners were now in the custody of the Charleston County Sheriff's Office, which was responsible for the operation of the jail and the custody of prisoners traveling to and from court. Duncan and Peeples were now under the purview of Sheriff J. Elmore Martin.

A Costly Stroll in the Morning Sun

Martin was a powerful political figure in turn-of-the-century Charleston. While Martin and City Police Chief Boyle were both Democrats, that was the extent of any commonality between the two. In short, they despised each other and looked for opportunities to step on each other's jurisdictional toes, just to hear the other squawk.

In 1891, John F. Ficken was elected mayor of Charleston. Ficken was an avid supporter of Governor Tillman, with whom the mayor had served in the state legislature. The mayor's first act was to appoint J. Elmore Martin as city of Charleston chief of police. Martin, from Barnwell, was also a close ally of Tillman. Martin quickly became Ficken's closest confidant and aide. An editor of the *News and Courier* described Martin as "a clean and likable man who preferred good company to bad and would rather the public affairs be well managed and in good hands. But his one aim and object in politics was to keep himself in office."

As the pendulum of politics swung back and forth, J. Adger Smyth won the Democratic nomination for mayor in 1895, which in effect made the general election a moot point, there being no credible Republican opposition. Smyth and his supporters, the Broad Street Ring, were adamantly opposed to Tillmanite policies and supporters. This heavy-handed net of politics snagged Martin on the first cast, and he was dismissed from his position as chief. This dismissal outraged the sitting governor, a Tillmanite as well, and he placed the city of Charleston under the jurisdiction of a special metropolitan police force and reappointed Martin as chief.

Martin held this post until 1898, when he stepped down to run for and was elected as sheriff of Charleston County. With a strong powerbase in the county, Martin would no longer be subject to the whims of the aristocrats on Broad Street.

As the old adage goes, "politics makes strange bedfellows." That tired saying was never more true than in the election for county sheriff in 1904. Charleston Mayor R. Goodwyn Rhett was tired of Martin sniping of his policies. Rhett, a member of the Broad Street Ring, turned to a political foe and Catholic populist, John P. Grace, and convinced him to run against Martin for sheriff, pledging the support of the mayor's office and his political cronies. Grace did run, even though he acknowledged it was a long shot to defeat the powerful incumbent. On election day, Martin defeated the upstart Catholic politician by a margin of four to one. Grace certainly took notice of the enormous margin of defeat in wards two, four and six as members of the Broad Street Ring refused to follow Rhett's recommendation, even if it meant supporting Martin. This debacle further solidified Martin's political base and gave Grace more reason than ever for his disdain of the Broad Street aristocrats.

Charleston's Trial

Martin was about to leave on his annual four-week vacation to his mountain home in Flat Rock, North Carolina, when the Jewish tailor was murdered. Knowing the sensational attention the case would generate, he postponed his trip to be sure he and his deputies were available as needed. Being out of town, he would have to relegate a deputy to function in the limelight of this sensational case. Men like Joseph Poulnot were capable men, but the potential for mob violence caused Martin to postpone his trip.

Duncan and Peeples made the short trip from the jail to the courthouse riding in the Black Maria. Martin led the procession aboard his horse, followed by other deputies on horseback, all heavily armed. In the middle of the procession was the horse-drawn wagon containing the prisoners, followed by more armed deputies brought in by Martin from the outlying rural beats. As the armed escort arrived at the courthouse, a large crowd was present on the streets, and the courthouse was packed to overflow, an unusual occurrence for a preliminary hearing.

Once the prisoner was ushered in and seated, Magistrate Williams called the hearing to order. These hearings were usually quick affairs, but fifteen witnesses were lined up to testify in the highly charged case at hand. Duncan's first charge was assault and battery with intent to kill. Joss Middleton, a fourteen-year-old black boy, first testified that he saw the accused in the Lubelsky store the morning of the attack. This testimony was followed by Mr. Isaac Goodman, who described the events on King Street, hearing Mrs. Lubelsky's screams, grabbing the accused and turning him over to police.

Next, Rose Lubelsky took the stand, recalling what she could of the attack and her identification of Duncan as the attacker. This was followed by a parade of police officers, including Detective Levy, Officers Hogan and Brennan and Private Stanley.

As soon as testimony was concluded on the assault, Williams heard testimony on the charge of murder. The black drayman Frost was brought in. The police had Duncan put on his hat and stand for Frost's identification, which of course he confirmed. Then detectives were recalled to the stand to testify about the clothes and jewelry seized at the tenement at number 48 Vanderhorst. Mr. J. Bluestein testified that the clothes were consistent with apparel at the Lubelsky store.

Finally, Max Posner was called to the stand to testify about finding Max Lubelsky the morning of the murder, though he offered no testimony that implicated Duncan.

Duncan was not placed on the stand and no statement was taken from him. At the conclusion of the tedious testimony, Williams promptly announced that Duncan would be held for trial on both charges at the next term of the

A Costly Stroll in the Morning Sun

Court of General Sessions. He further pronounced that the accused would be held at the Charleston County Jail without bail. Duncan sat through the long hearing in a stoic fashion, offering no emotional reaction to the magistrate's findings.

Peeples was quite different, acting uneasy throughout the proceeding and crying aloud when Magistrate Williams announced that he would be sent to jail for receiving stolen property. On the ride back to Magazine Street, Peeples continued his protestations. Duncan, never one to converse much, remained silent. Upon arrival at the jail, Duncan was placed in a single cell on the third level.

Peeples was placed in a large holding cell with many other prisoners to await transfer. The next morning, Peeples was transferred to a stockade in St. Andrews Parish, across the Ashley River, to serve his sentence on the chain gang.

Duncan, now awaiting trial, settled into his six- by nine-foot cell, located in a large room occupied by many other similar cells. The jail, in 1910, served a role as purgatory for most prisoners, a place they were subjected to while waiting to reach their ultimate destination. Criminals who received sentences of fewer than ten years were transferred to one of two stockades in St. Andrews Parish to pass their time on the county chain gang. Criminals receiving sentences of more than ten years were at the jail until their eventual transfer to the state penitentiary could be accomplished.

The final group consisted of prisoners awaiting a hearing date or trial in the next Court of General Sessions. On a rare occasion, a prisoner would be held in the county jail awaiting execution, a public spectacle that had occurred only twice in the first ten years of the twentieth century. In 1910, a total of 3,700 prisoners would serve time or pass through the Charleston County Jail, with as many as 90 to 120 people incarcerated there at any one time.

Exuberant over Duncan's arrest and the successful preliminary hearing, Boyle decided to release Henry James and Anthony Jour, who were still being held under suspicion. This was done without any opportunity for chief witness Charles Karesh, who was still out of town, to identify Jour. Karesh had previously expressed some indecision about James, but had refused to rule him out. Their release was important as an expression of the police department's confidence that Duncan was the one true murderer.

Duncan spent his time awaiting trial in silence, choosing to speak to neither the jailors nor his fellow prisoners. His family began a daily ritual of delivering meals to the jail for him three times a day. The practice was permitted and, in fact, welcomed by the sheriff and jail staff because it eased

Prisoners at the Charleston County Jail, awaiting transfer to the chain gang, circa 1910. *Courtesy of the South Carolina Historical Society.*

A Costly Stroll in the Morning Sun

Above: Prisoners at the Charleston County prison farm in St. Andrews Parish. *Courtesy of the South Carolina Historical Society.*

Right: Prisoners working on the Charleston County chain gang. *Courtesy of the South Carolina Historical Society.*

the financial pressure on the county to feed the wards of the jail. Those prisoners who were not as fortunate to have a devoted family assisting their stay were subjected to the standard fare prepared by the jailor's wife and a jail trustee, meals consisting of water, salt meat, hominy and corn bread.

Duncan was also visited by Mr. Geilfuss, who treated Daniel to slices of A.G. Bread and pastries from the shop. Duncan missed the rhythm of the daily demands of his job as a baker. He realized he had taken his job for granted after thirteen years and missed the enticing aromas and the excitement of learning a new recipe.

But while all these visits were welcomed, Duncan was greatly distressed to be separated from Ida Lampkin, his fiancée. Were it not for his arrest, he would be married and enjoying life with his young love. Ida was equally devoted to Duncan, but her mother forbade her any visit to such a loathsome place as the county jail. The best she could do was to send notes to Duncan frequently, delivered by his family with his meals.

On July 19, the solicitor, John H. Peurifoy, began hosting review sessions in his office to discuss evidence and prepare witnesses for trial. Peurifoy, who enjoyed an excellent record in securing convictions, was brought in from Walterboro to prosecute the case. His presence alone was a clear sign that the city wanted this trial to proceed quickly with a guilty verdict. Peurifoy was assisted by Mr. Joseph Patla.

Peurifoy was a man who had worked hard for what he had. Legend held that he rode a mule from Walterboro to Newberry to attend college. He later transferred to Wofford College after earning a scholarship, though he still had to earn funds from teaching to help pay his way. After graduation, he earned his law degree at the University of Virginia and then returned to South Carolina to practice law in Saluda County. He later returned to Walterboro, joining his two brothers to form Peurifoy Brothers law firm. He also operated Pineland Stock Farm, raising Berkshire and Jersey cattle.

All of the witnesses testifying in the preliminary hearing attended. Though he was pleased with the progress of the murder case and with the capture of Duncan, Peurifoy was determined to leave nothing to chance in this highly charged trial.

Anxious to try the case, Peurifoy announced in late July that he would petition Governor Ansel to call for a special session of court for the trial. Peurifoy cited the high emotions in the city and the intensity of the city's racial tensions as reasons enough to expedite this important case. Ultimately, the governor decided against a special court session, claiming that the expense would be too great.

A Costly Stroll in the Morning Sun

Confident in his innocence, Duncan could not have appreciated the magnitude of the challenge before him and his defense attorney to secure his acquittal in the upcoming trial. Though naive in the comfort of the thought of his innocence, he passed his time with thoughts of his gentle, loving Ida and the hope of their eventual marriage. Almost ninety days would pass before his opportunity to declare his innocence at the next Court of General Sessions would arrive.

By late September, the Court of General Sessions would be convened. It was to be a busy session, with thirty men and three women facing charges and trials in myriad cases. The court would hear eight capital cases, though Duncan's charge was the only case involving a white murder victim.

With Duncan safely tucked away in the county jail, Sheriff Martin finally left in late August for his Flat Rock, North Carolina summer home. On September 25, Martin returned, refreshed and ready to tackle the security concerns of the trial and the sure execution to follow. He had no intention of letting a mob usurp his authority.

Even before the start of the trial, the issue of who might receive the considerable reward offered in the Duncan case was in much debate. Immediately after the murder, the mayor offered a reward of $150, funded by the city. Governor Ansel then pledged an additional $100 to be added to the city reward. Mr. I.M. Monash, a Jewish merchant on Market Street, later contacted the investigating police officers to announce a $500 reward to be offered by Max Lubelsky's countrymen.

Speculation in Little Jerusalem was that the rewards should be paid to the detectives investigating the case, as they were the men who would ultimately ensure that Duncan paid the ultimate price for his crime. Isaac Goldman and Moses Needle had already filed a claim for the reward as the two men who first grabbed and restrained Duncan. Others in the community felt the reward should be paid to Private Stanley, since he was the actual arresting officer. Finally, in late August, Abram Tandater, a King Street shoemaker and clothier, also filed a claim for the reward at city hall, stating that he "first touched Duncan and arrested his flight" just before Goodman and Needle grabbed him. Tandater offered to produce J. Neylor, a Sumter Street awning maker, as a witness to his claim. With multiple and competing claims for the lucrative reward, the mayor's office announced that nothing would be paid to any claimant until after the completion of the trial.

CHAPTER 6
A Simple Coat and Hat

The day finally arrived for the case of the *State of South Carolina v. Daniel Duncan* on October 6, 1910. The highly anticipated trial would be conducted in the Court of General Sessions at the Charleston County Courthouse on Broad and Meeting Streets in Charleston. Located at the site of the colony's first statehouse, built in 1753, the courthouse was one important piece of the famed "Four Corners of Law," the four buildings at the intersection representing God's law, the City's law, the County's law and the Federal law.

In 1788, the building, on the northwest corner of the intersection, was designated to serve as the courthouse for Charleston County. In 1883, the courthouse was remodeled to enlarge the courtroom on the second floor. The *News and Courier* provided an account of the changes and a description of the courtroom:

> *The judge's seat is on a raised platform at the west end of the room, and on each side of the judge's seat are desks for the sheriff and the stenographer… The ceilings, which are high and airy, are surrounded by wooden cornices, and the side walls are relieved by fluted wooden pilasters. There are three chandeliers suspended from the ceiling and bracket lights on the side walls, making in all 38 gas jets in the room. At the back of the judge's desk is an arched doorway through which entrance is gained to the judge's private room. In the space over the door is a palmetto tree with the coat of arms of the State at the base.*
>
> *The courtroom is painted in two shades of drab, the railings dividing the room being of black walnut, and the ceilings and side walls being left white. The acoustic properties of the room are excellent…The jurors will sit on platforms on the north and south sides of the room and the witnesses will occupy stands on either side of the judge's stand.*

Charleston's Trial

The Charleston County Courthouse, at the corner of Broad and Meeting Streets, circa 1910. *Author's collection.*

The Court of General Sessions opened on the morning of October 6 with the trial of London Bowles, who was indicted for "breach of trust with fraudulent intent," continuing from the previous day's session. The jury, with its work completed, returned to the courtroom in the late morning with a verdict of "not guilty." The verdict was announced as the packed courtroom understood the completion of the Bowles case cleared the way for the case of Daniel Duncan.

The courtroom's design provided a small Negro section, which was marked off by a wooden rail. The section was conspicuously vacant, however, as the Duncan trial opened. Even though the trial held great interest in the black community, no black person wanted to risk putting himself in the midst of this agitated crowd. Packed as the rest of the courtroom was at noon, none of the white observers would take a seat in the Negro section.

Duncan was brought by wagon from the Charleston County Jail to the courtroom under heavy guard. With shackled hands and feet, the accused was marched upstairs and into an anteroom to meet with his attorneys before the start of the trial. Deputy Sheriff Joseph Poulnot stood guard at the door. Brice Mathews, an attorney in private practice, had been appointed to serve as defense attorney. Mathews was originally from Howard County, Maryland, and had moved to Charleston in 1897 to pursue the practice of law. He was seated with Paul MacMillan, a twenty-six-year-old attorney in

the city who was assigned to assist in the defense. This was, in fact, the first time the two defense attorneys had even set eyes on their client.

Initially, Duncan's appearance startled MacMillan. Soiled and reeking of body odor, Duncan presented a pathetic figure in his heavy shackles. Duncan took his seat on the opposite side of the table without comment. Mathews sat quietly for a moment, assessing his new client. He hardly looked like a formidable and violent killer.

Judge R.C. Watts, of Cheraw, moved immediately from the Bowles verdict to call the court to order just after twelve noon for the *State v. Daniel Duncan*. As the accused was marched in, he quickly took in the scene in the packed courtroom.

Duncan had just been ordered to proceed toward the bench when Rose Lubelsky jumped to her feet, lunged toward the defendant and screamed, "YOU KILLED MY HUSBAND! WHY DIDN'T YOU KILL ME?" She was stopped by a sheriff's deputy before she reached Duncan and was led out of the courtroom by several friends who had been sitting with her. This dramatic outburst clearly unnerved the large crowd, but if it affected Duncan at all, he showed no sign of it.

Judge Watts called for order to be restored as Sheriff Martin escorted Duncan to the dock enclosure to take his seat. Mrs. Lubelsky was taken to another room, "where restoratives were applied and her nerves quieted." Once she regained her composure, she reentered the courtroom to take her seat.

The first order of business was to empanel a jury. Men from the jury pool were interviewed. Four men were dismissed after objection from the defense, three were dismissed by the prosecution and two were dismissed by the judge before a jury of twelve men was seated to hear the case at hand.

Robert Lebby, owner of Lebby Shoe Company and superintendent of the First Scots Presbyterian Sunday School, was chosen as jury foreman. The remaining members were George Bell, a salesman with Thomas & Brothers; Lawrence Bicaise, a gun and locksmith on Meeting Street; D.S. Burnett, a machinist with Southern Railroad; Henry Calder, a store clerk; Horatio Hughes, a bookkeeper with First National Bank; E.L. Miller, a foreman with Franke Carriage Works; E.B. Morgan, a day laborer; Mark Morrison, superintendent for City Carts; Thomas O'Brien, a pharmacist; M.P. Refo, manager of Peacock Chemical Company; and George Scott, a bookkeeper with C. Wulbern & Company. Though the standard practice of the times would have it no other way, a jury of twelve white men was not exactly a jury of Duncan's peers.

With the jury selection complete and in place, the prosecutor was instructed to call his first witness. Peurifoy called Dr. Pearlstine. After several

John H. Peurifoy, prosecutor for the *State of South Carolina v. Daniel Duncan*. Courtesy of the Peurifoy family.

preliminary questions, Peurifoy asked where he found Max Lubelsky on the morning of June 21. Pearlstine responded, "I found him between two tables lying on the floor, bleeding very profusely. I could not do anything for him there so I told the policemen to carry him to Riverside Hospital. When he got to the hospital I had his head shaved and found three large lacerations in his scalp, one in the back of the head, one over to the right and the other about here (indicating the top of the head). He lived for about half an hour after we got him there."

Mrs. Lubelsky sobbed continually through Pearlstine's testimony. Peurifoy continued by asking, "In your opinion, Doctor, what was the cause of Max Lubelsky's death?"

The young doctor offered, "After we performed the post mortem that afternoon we found a fractured skull and hemorrhage of the brain, half a dozen or more fractures. It seems as if the skull was beaten into a pulp, the bones and scalp also." After several additional questions for clarification,

A Simple Coat and Hat

Brice Mathews, Esquire, defense counsel for Daniel Duncan. *Author's collection.*

Peurifoy took his seat. Mathews indicated he had no questions for Dr. Pearlstine.

Peurifoy called his second witness, Max Posner, the peddler who was the first person to find Lubelsky after the attack. He explained his visit to the shop, stating, "When I came in I was with a little girl four years old, I never saw anyone in the store. He [Lubelsky] has some pigeons and chickens in the back and I usually find him there so I went through the store in the back yard and I never saw anyone there."

Peurifoy asked again, "And you didn't see anyone there?"

"No, sir," the peddler responded. "Then I came back and my child said she was tired and I put her on a high chair. I was lying down on the counter to wait for him, I thought maybe he was outside talking to someone and I was waiting, and in that time when I was lying down on the counter I found his body between the two tables."

Peurifoy then asked, "What was his condition?"

Posner replied, "He was in blood. I was so excited and I went to his head and tried to feel his head and I tried to talk to him, then he started to wipe his blood. He could not say anything in the time I found him; he was like most dead. When I started to feel his head he moved."

Peurifoy asked again, "Did you find anyone?"

Posner said, "I didn't find anyone. I went out the door and called Mr. Karesh, right next door. He told me he didn't have anyone to leave in the store, and then I went and called a policeman, Mr. Stender."

After Peurifoy concluded this time, the defense counsel did have questions for the witness. Mathews asked several questions of Posner, covering repetitive topics to warm him up. He then focused on questions and concerns about the changes in the crime scene between when Posner first discovered Lubelsky and when Posner returned with the policeman.

Mathews asked, "Was the store in disorder?"

Posner responded, "I was never looking to see if it was out of order, I was just looking for a person in the store."

Mathews pushed it further asking, "If it had been in disorder would you have noticed it?"

Posner responded, "I don't know what you mean."

Clarifying, Mathews asked, "If everything was thrown around you would have noticed it?"

Posner acknowledged, "Yes."

Mathews asked again, "And you didn't notice anything?"

"No, sir," Posner said.

Now that Mathews had started highlighting discrepancies in the crime scene, he suddenly stopped this line of questioning and followed with questions about the reason for Posner's visit to Lubelsky's store and his habits as a peddler, never to return to the delicate subject of the crime scene.

Peurifoy next called Charles Karesh to the stand. Karesh was the chief witness to place Duncan at the scene of the crime.

After only a few preliminary questions, Peurifoy got right to the heart of the matter by asking, "Mr. Karesh, you saw this man here, Duncan?"

Karesh answered, "Yes sir, I saw him that morning, the twenty-first of June."

Peurifoy next asked, "Are you sure he is the same man?"

Karesh responded confidently, "Yes sir, I am sure. I know it."

Peurifoy then inquired, "What time did you see him this day?"

Karesh recalled, "From nine thirty until about ten thirty, until I walked up to him. He had a wire eight-penny nail, a piece of wood with a nail in it."

A Simple Coat and Hat

Peurifoy, now holding the piece of wood recovered at the scene of the crime asked, "Is this the piece of wood?"

Karesh looked at it and said, "Yes sir, that is the very one. I walked up and asked him what he was doing there. He didn't answer me anything. He walked up to the window and looked in there and then went in the store."

Peurifoy followed, "You say you saw him go in this store [referring to Lubelsky's]?"

Karesh responded, "Yes sir, but he didn't have on those clothes [pointing to Duncan and his clothes], he had on a double-breasted coat and stiff hat."

After several questions about Karesh's familiarity with the Lubelsky family, Peurifoy asked, "What took place when you saw him go in this store on this occasion?"

Rather than answer the question directly, Karesh anxiously contradicted Max Posner's earlier testimony stating, "That witness before made a mistake. He was excited, he called me and I went right in there and stayed there. He [Lubelsky] was lying between the counters. I grabbed him by his shirt and tried to pick him up; he shook his head and moved his arms twice. That slat was lying there."

Once Peurifoy concluded, the defense counsel began a rapid-fire, aggressive questioning of Karesh. After inquiring about his identification of Duncan at the police station, he asked, "What time in the morning of the twenty-first did you see Max Lubelsky first?"

Karesh replied, "I used to get up about six thirty or seven. I talked to him at ten. I lent him the paper and went to get it back. There was not a soul in there but him."

Mathews then focused on the testimony that he saw Duncan walk into Lubelsky's store.

Mathews asked, "The man you saw standing there with the slat, did he speak to you?"

Karesh said, "No."

Mathews inquired, "You spoke to him?"

Karesh then stated, "I asked him what he was doing there."

Mathews asked, "What did he say?"

Karesh replied, "I believe he answered me nothing, but he looked in the window and went in."

Mathews pressed further, "Did you tell him to move away?"

Karesh admitted, "No, he kept right on."

Mathews was not satisfied. "But you asked him what he was doing there and he walked off?"

Karesh then said, "He looked in the glass and walked right in the store and that is the last I saw of him until I saw him in the jail on the fifteenth of July."

Mathews turned to the issue of Duncan's clothing, "You know that coat and hat?"

Karesh answered, "Yes sir."

Mathews wanted to know more. "Know it well?"

Karesh's response was again straightforward, "Yes sir."

Mathews inquired, "Do you know where that hat and coat have been since the murder of Max Lubelsky?"

Karesh was confused, "I don't know, all I know is the one."

Mathews insisted, "You could recognize that hat and coat wherever you saw it?"

Karesh answered, "Yes sir, that is the very one he had."

Mathews continued, "And when you saw him in the jail with four others—"

Karesh corrected him, "Five others."

Mathews returned to his question, "He had that hat and coat on?"

Karesh was sure. "Yes sir."

Mathews wanted information on the others in the lineup. "Did they have hats and coats like that?"

"A good many had blue coats," Karesh recalled.

"And hats?" Matthews added.

Karesh responded, "Some of them did?"

"But you were more familiar with that hat and coat?"

Karesh, still a bit confused, replied, "I knew his face. He has a round face."

Mathews continued, "And he was garbed in that hat and coat as he was standing there?"

Karesh answered, "Yes sir."

"You spoke to him?"

Karesh responded, "I asked him what he was doing there."

"What did he say?"

Exasperated, Karesh said, "I believe he answered me nothing, but he looked in the window and went in."

Mathews then inquired about Karesh's knowledge of and interest in the $500 reward offered by the Jews in Charleston for information leading to the capture of the murderer of Max Lubelsky. Karesh insisted he knew nothing of it and did not contribute to it. Mathews pushed Karesh regarding his unwillingness to contribute to the reward fund, stating, "You would give anything but money?"

Karesh changed his mind and insisted, "I would give money if it was necessary."

A Simple Coat and Hat

Having Karesh now on the defensive, he asked, "But you didn't have time to leave your store to see about your friend?"

Karesh fired back, "He (referring to Posner) made that mistake. I went right in there. I said you go look for an officer."

Artfully, Mathews came back to the issue of the hat and coat. "If you saw that hat and coat on any man, could you pick it out?"

Karesh tried to distinguish. "No, if I don't know the face I would not pick it out."

Mathews continued, "But you told me just now you were familiar with the hat and coat."

Karesh asserted, "I saw that one (pointing to Duncan) with the slat and suspicioned him."

Mathews asked, "How long did he stay in front of your door?"

Karesh thought a moment and answered, "Half to three quarters of an hour."

Mathews asked, "And he never said anything?"

Karesh again answered, "No, he had his hat down to here (indicating on his own head) and his coat was buttoned up like he was freezing."

Mathews noted the odd way the man was dressed. "Ten o'clock in the day, the sun was on that side?"

Karesh responded, "Yes."

Mathews continued with rapid-fire questioning, highlighting more inconsistencies in Karesh's testimony.

Mathews asked, "And he never said a word to you when he left your store, although you said, 'What are you doing there?'"

Karesh hesitated, "Maybe he did say something, I didn't think he did, he looked in the glass where the man had some clothes and went in the man's store, and that is the last I saw of him until the jail."

Mathews looked right at Karesh, "You say he didn't speak?"

Karesh replied, "I don't think he did."

Mathews could tell that Karesh was not as confident as he had been with his previous answers. "Would you remember if he spoke?"

Karesh was reserved. "Maybe he did. I don't remember."

Mathews asked for a clarification. "When you asked him what he was doing there, he said nothing and moved away?"

Karesh admitted, "He moved a little bit."

Mathews's next question was mildly sarcastic. "Did you notice anything peculiar about the way he said nothing?"

Karesh was becoming more nervous. "Everything I was noticing was that slat. I would not have noticed if it didn't have that nail. I was looking for something."

Mathews snapped, "You did suspect that he was up to something?"

Karesh, tiring of the questioning, answered, "I don't know."

Mathews went on. "So you saw a suspicious man go into Mr. Lubelsky's store?"

Karesh could not focus. "I don't know."

Mathews pushed harder. "Didn't you say he went into the store?"

"Yes," Karesh finally responded.

Mathews again probed, "He was suspicious?"

Karesh retracted his previous assertion. "No, he was not exactly suspicious. If you passed me with a thing like that I would suspicion you."

Mathews could not help himself. "And if I put that hat and coat on you would recognize me?"

Karesh affirmed, "No."

Mathews then asked the witness, "You don't remember how many men you tried to identify?"

Karesh could not recall. "No."

"Did they have that hat and coat on?"

Karesh again could not recall. "I don't recollect."

Mathews needed to drive the point home for the jury. "Could you pick that hat and coat out of a thousand in a pile?"

Instead of directly answering the question, Karesh asserted, "I could pick out his face."

Mathews strained to get the truth—that only Duncan had been garbed to ensure the identification. "And when you picked him out of the lineup, the defendant had been dressed in that hat and coat?"

Karesh's answer was all Mathews needed. "Yes sir."

Mathews's cross-examination had been effective. He pointed out Karesh's inconsistencies and highlighted for the jury that Duncan was picked out of a lineup dressed in a hat and coat that exactly matched the clothes described by Karesh as worn by the black man outside the store on the morning of the murder.

Additionally, Mathews noted that Karesh took great exception about Posner's testimony that he would not help or sit with Lubelsky as Posner ran for the police.

Peurifoy felt he needed to redirect for the prosecution, and he said to Karesh, "Counsel has asked you something about the reward. I believe you stated you didn't contribute anything for the reward."

Karesh responded, "No."

Peurifoy then asked, "But in addition to what the governor offered, the citizens of the city did contribute something?"

In response, Karesh offered, "They thought to get together and get it up, but no one made it up yet."

Seizing on this as yet another inconsistency in Karesh's testimony, Mathews chose to reexamine the witness. "You told me you didn't know anything about $500 reward, that you had given nothing and knew nothing about it, but you say you did know they were netting up a reward, but didn't make the collections?"

Karesh was shaken by the inquiry. "They were talking about it."

Mathews asked, "You knew they were talking about it?"

Karesh said only, "Yes, sir."

Mathews then asked, "You have done a lot of talking yourself?"

Karesh said, "Yes, sir."

Mathews questioned further. "Then the newspapers misquoted you?"

Karesh did not follow the question. "What newspapers?"

Mathews was losing patience. "Don't you know what a newspaper is?"

Karesh responded, "Yes."

Mathews's next question was pointed. "They have misquoted you?"

"I don't know what you mean."

With that, Karesh was allowed to step down. The next witness called by the prosecution was Frank Frost, a drayman who said during the investigation that he had had a conversation with a black man in Lubelsky's store the morning of the murder. He later identified Duncan as that same man in a lineup at the jail.

Peurifoy walked Frost through a line of questions establishing his identity, residence, occupation and the several deliveries he was making on June 21. The key to his testimony was when he was finally asked, "Did you see Max Lubelsky at the store?"

Frost responded, "No sir. I found this young man there (pointing to Duncan)."

Peurifoy insisted, "Are you sure it was this man?"

Frost stated, "That is the one who spoke to me in the door."

Peurifoy inquired, "What time was that?"

Frost estimated, "Between eleven and twelve o'clock."

Peurifoy then inquired, "What did this man say to you there?"

Frost gave a detailed reply. "When I drove up to the door I didn't see Mr. Lubelsky, I saw him and I asked him where Max Lubelsky was. He told me that he went across the street, and after he told me he went across the street I threw the case off the truck and was looking across the street. I thought he was over to Mr. Jacobs, but he didn't come. I waited for about a quarter of an hour."

Peurifoy was curious. "Why did he say he was in the store?"

"He told me he was the porter."

"The porter for Max Lubelsky?"

"Yes sir, said Mr. Lubelsky hired him there for one week, then he went in the back of the store, he put his coat and hat on and came back to the door. I left him in the door when I drove off."

Peurifoy was done with Frost, knowing that his testimony clearly hurt the defense. Another eyewitness had placed Duncan at the store.

Mathews approached the witness, invoking the same questions about some unusual trait or characteristic of the defendant. "Was there anything about the man you saw there that impressed you very much?"

Frost recalled nothing. "No sir."

Mathews then asked, "How was he dressed when you first saw him?"

Frost thought briefly and said, "He had on a clean white shirt and collar and a black tie."

Mathews returned to a previous point. "When you saw him, you say he put on a coat and hat?"

"While I was waiting for Max Lubelsky he went in the back of the store and put on his coat and hat and spoke to me. That is the time I drove off and left the case in his charge," Frost clarified.

Mathews asked again, "And you noticed nothing peculiar or striking to make you take particular notice?"

Frost was certain. "No sir."

Mathews turned to the lineup. "When you identified this man, did he have that hat and coat on?"

"The coat he had on was a cleaner looking coat and hat," Frost recalled.

Mathews repeated Frost's answer. "It was a cleaner looking coat and hat when you saw him in Lubelsky's store?"

"Yes sir."

Frost then stepped down, and Peurifoy called Viola Gibbs to the witness stand. She testified that she had collided with a black man running with a bundle of clothes on the morning of the murder. She identified Duncan as the man who ran into her.

Mr. C.A. Joseph, a salesman working for Jacob Needle on King Street, was then called to the stand. After a few preliminary questions, Peurifoy asked if he saw Duncan on July 8, the day that Rose Lubelsky was attacked.

Mathews jumped to his feet to object. "This defendant is being tried on an indictment, which charges that on a given date he killed and murdered a certain person, now they are trying to prove that on the eighth of July, three weeks after this occurrence, that this man was seen somewhere else, but it has nothing to do with this indictment."

A Simple Coat and Hat

Judge Watts immediately overruled Mathews, announcing, "I think they have a right to show where they saw this man that day."

Peurifoy continued. "All right, Mr. Joseph, just tell the jury under what circumstances you saw him."

Joseph recollected, "On the eighth day of July I saw Daniel Duncan standing in Mr. Lubelsky's store with some goods. I noticed him very closely because he had a stick of wood in his hand, looked like a one-cent stick of wood. I went in the yard when I heard a woman scream twice, and when I got to the door this man had been caught by two gentlemen and I identified him at the police station."

Peurifoy then asked, "Is this or not the same man who came out of the store on the eighth of July?

Joseph was clear. "I didn't see him come out, I saw him after he was captured."

Next Peurifoy called Mr. S.J. Griffith, an employee of Rhodes Furniture, to the stand. Griffith testified that on June 24, Daniel Duncan came to the store at 359 King Street and paid $24 for a parlor set and $5 down on a bedroom set. The implication was that Duncan was freely spending money after the murder of Lubelsky, though no one had established any amount of money stolen the day of the murder.

Officer W.H. Stanley was the first police officer to testify. Officer Stanley was on King Street the day Rose Lubelsky was attacked. Stanley testified, "I saw a crowd and I went up there and they turned the Negro over to me and told me he hit Mrs. Lubelsky with a stick of wood. I carried him to the box and sent him in. Mr. Levy went to the station with him. I went in Mr. Lubelsky's store and found a stick of wood behind the showcase."

Following Officer Stanley, Detective Clarence Levy was called to the stand. Levy described the scene in Lubelsky's shop when he arrived just after the murder.

> The tables were North and South and he had clothes on them, and he was lying this way (indicating to the jury), his feet to the Northeast and that stick was lying to the left of him. He was in a pool of blood. I questioned around to try to find out something and, in the meantime, Dr. Pearlstine came in and examined the man. I found out afterwards that Officer Stender telephoned for the wagon to send him to the hospital. I waited until the wagon came and sent him to the hospital, then I went and looked around, and in the back room I found the till with the change scattered around in a little room on the back. I noticed the safe door was open and I found on the counter one of those little boxes belonging to a safe with a lot of checks scattered on the counter.

Charleston's Trial

> *After that we sent the man to the hospital and I left Officer Shultz in charge, and myself and Officer Stender went to the station house and got horses and rode up to the junction, making inquiries and also stopped several drays.*

Peurifoy asked, "You did all you could to find the guilty man?"
"Yes sir," responded Levy.
Upon questioning by Peurifoy, Levy went on to discuss the events of July 8.

> *On the eighth of July I was coming up King Street, just below Anne Street. I saw several men running across the street and saw a colored man run and I hurried up. When I got there they had him, and Officer Stanley was ahead of me, and they had turned him over to him. I got some information and I met John Hogan. I saw him on the car and beckoned him. He got off and we went back to the station house and took Duncan where he lived. We asked him where he lived and he said 48 Vanderhorst Street below Coming Street back in an alley. So myself, Officers John and James Hogan went there and searched his premises and we found two coats and a vest and some jewelry. The jewelry was hid under a pillow downstairs.*
>
> *We went back to the station house, and I think they received a telephone message that some clothes had been thrown over the fence in that alley and Officers James Hogan and Brennan went there and got them.*

Peurifoy inquired, "Did you ever see any of this jewelry in the store of Max Lubelsky?"

Levy responded, "Yes sir, the showcase alongside the safe contained such stuff as that. We took the stuff up there and it corresponded with the stuff in the show case."

Peurifoy then asked, "Mr. Levy, did you ever have a conversation with Daniel Duncan about where he got these clothes?"

Levy answered, "Yes sir. He claimed he bought some from Banov and Volaski and some from S. Brown, said he was dealing with them and had an account with them."

Levy's testimony concluded the first day of court. Before adjourning, Judge Watts shocked all those present, and particularly the jury, by announcing that the jury would be confined until the trial ended, a practice that was most rare in Charleston. Judge Watts swore in county policemen Burton and Nelson, who were assigned to guard and protect the jury. The court made arrangements for the jurors and policemen to stay at the Charleston Hotel, where they would remain until the court reconvened the next day.

CHAPTER 7

A QUESTION OF SPEECH

The *News and Courier* published a full account of the first day of the trial, providing provocative reading at the breakfast table for Charlestonians. The courtroom opened at 9:00 a.m. on Friday to receive the anxious crowd hoping to squeeze into the county courtroom for the second day of the trial. The paper's reporter observed, "Every available inch of space in the Court room was taken by the throngs that gathered to hear the conclusion of the interesting case."

Duncan was brought over early from the county jail under heavy guard, held in another chamber and escorted into the courtroom just before 10:00 a.m. At precisely the top of the hour, the bailiff called for all to rise, and Judge Watts entered and assumed his position to preside over the charged courtroom.

The prosecution first called Officer John Hogan to the stand. Like too many members of the police department, Hogan, at sixty-two years old, was long past his prime and incapable of handling some of the physical demands of police work. Police Chief Boyle handled the issue of Hogan's age as he had that of several other long-tenured men. Hogan was promoted to detective, thus removing him from the rigors of street duty.

Hogan, on Peurifoy's instructions, gave a full account of the crime scene on the day of the murder and the visit to Duncan's home, with the same detail as Detective Levy had provided on the first day of the trial. He also described the early investigation of the murder, stating, "We arrested almost everyone we had any reason to believe was connected, or would do anything of that kind. We brought in five or six. We knew that Mr. Karesh would be able to identify the parties, and on each instance when we brought these people in, we sent for him, and he failed to identify any until we got Duncan."

Hogan continued to discuss the evidence of the clothes and jewelry found at the apartment. He reiterated Duncan's claim that his clothes were bought

at Brown's, and others at Banov and Volaski's. He stated Duncan claimed the jewelry was purchased at a ten-cent store.

On cross-examination, Mathews went back to the issue of the many arrests prior to Duncan, pressing Hogan on the probable cause for the arrests. Hogan described that six or seven men were arrested and, of the group, two were committed to the county jail for further examination. Hogan admitted, "We had reason to believe they might be connected with it [the murder]."

Mathews then pushed the issue of the clothes seized at Duncan's apartment, asking, "Was there not considerable confusion as to the identity of certain goods brought in?"

"I don't think so."

Mathews wanted more information from the preliminary hearing. "After a good many of these goods were identified, were not several things thrown out?"

"There were some goods we had brought in and I didn't know whether they were the property of Max Lubelsky or not," Hogan admitted. "We were under the impression they were, but Mrs. Lubelsky came and picked out the goods which we considered were not her property."

Mathews knew that Hogan was agitated. "After they were identified as hers?" he asked.

Hogan was short. "No, I told you we had brought them in with others."

Mathews refused to back off. "Was not there considerable confusion as to the values, a good deal of prompting by all of her friends as to what value, so much so that Magistrate Williams remonstrated with them?"

Hogan said, "Well there was, but how much I could not remember."

Mathews then opened up another line of questioning about confrontations within the Jewish community. He inquired of Hogan, "Don't you know that among nearly all of Lubelsky's countrymen there has been a factional fight for years?"

Hogan answered, "I never knew of any of them fighting each other."

Mathews clarified his question. "I mean a feudal disturbance among them."

Hogan responded, "I cannot say. As a general thing, they are loyal people to one another."

Peurifoy now jumped to his feet to object to this line of questioning, citing lack of relevance. Mathews knew what many in the city knew—that there were serious divisions in the Jewish congregation at B'rith Shalom synagogue, where Lubelsky, Karesh, Posner and many others were members.

Shouting matches and demonstrations had occurred as the Jews made their feelings known about the idea of doing business on the Sabbath and

other issues of orthodoxy. It was clear to everyone in the courtroom what Mathews was inferring. A serious schism had occurred in B'rith Shalom synagogue, resulting in rumors about some members leaving to form a competing synagogue.

Judge Watts overruled Peurifoy's objection, but Mathews did not push the issue further, perhaps sensing that Hogan would not open up on the issue.

Mathews did probe the issue of the identification of Duncan by Mrs. Lubelsky for the attack on July 8. He noted that Duncan was presented to her at the back gate of her store, accompanied by two police officers, rather than having her come to the station and face a lineup of many men. Mathews offered, "So she knew Duncan was in the charge of an officer when you carried him up there?"

Hogan simply responded, "I expect she did know we were officers. I told her my mission."

Mathews probed the issue of the description released after the June 21 murder of the probable assailant, asking, "What was the description you received?"

Hogan responded, "That it was a young negro thirty-two or twenty-four, wearing a dark suit and a stiff hat, about five feet, six inches high." Mathews added that the description at the station house also made mention that the assailant was a mulatto.

Finally, Mathews asked about the other men arrested. "None of these men were released until after the assault on Mrs. Lubelsky?"

Hogan said, "I think after the day of committing this man."

Mathews pointed out that suspicion was so strong about two other men that they had been retained in jail and released only after Karesh identified Duncan.

Next, Peurifoy called Detective John Brennan to the stand. Brennan, like many on the Charleston police force, was an Irish immigrant. Recalling a conversation at the police station on the day Duncan was arrested, he reported that the suspect said "he was on King Street to buy clothes. In searching his pockets we found some invitation cards. He had issued a number to different parties, said he was going to get married, that he admitted to being in Mrs. Lubelsky's store the same day. The invitations are in the coat pocket, I think, unless they have been taken out recently." Holding up the invitations as he pulled them from the coat, Peurifoy asked, "Are these the papers found in the coat?"

Brennan confirmed that they were.

Peurifoy offered the invitations into evidence and read one for the court.

CHARLESTON'S TRIAL

Mrs. Mary Lampkin
Requests the honor of your presence at the
Marriage of her daughter
Ida
To
Mr. Nealy Duncan
On Wednesday evening, July thirteenth
One thousand nine-hundred and ten
At eight o'clock
At home No. 4 Palmetto Street
Charleston, S.C.

Brennan clarified that Duncan's full name was Daniel Cornelius Duncan, and Nealy was a nickname.

Brennan also described bringing in Mr. Brown and Mr. Banov to look at the clothes recovered from Duncan's apartment. He testified, "They said they never kept such shoddy stock as this, they knew nothing at all about them and Duncan never bought from them and they didn't have his name on their books."

Listening to the testimony, Mathews understood that the other Jewish merchants were not about to admit to anything that might benefit the defense.

Under cross-examination, Mathews, pointing out some of the clothes introduced, asked Brennan, "Is there not a man now on bond under an indictment in this court for receiving stolen goods who was examined before Magistrate Williams and committed by him?" In doing so, Mathews was referring to Peeples.

Brennan answered, "I don't know."

Mathews asked, "You were at the examination?"

Brennan said, "I was."

Mathews then asked, "Who does Mr. Momier represent?"

Brennan thought for a moment and said, "A man named Kiser."

"Was he not put in jail and subsequently released on bond?"

"I don't think so, I don't know, I am not sure of that."

Mathews again asked, "He was a suspect of having received stolen goods?"

Brennan clarified, "No, we found some of them in Kiser's room but his possession was satisfactorily explained by other witnesses living in the yard."

Mathews insisted, "It was not explained until Lubelsky's friends and detectives got working together!"

A Question of Speech

Brennan did not like the insinuation. "Oh, no!"

With Brennan appearing on the defensive, Mathews pressed him on several other issues. At least he was able to divulge that just about everyone in Duncan's tenement who could be caught was charged with something.

Mathews questioned, "When you arrested Jones you thought you had the man who killed Lubelsky?"

Brennan answered, "I might and I might not."

Mathews pushed the issue. "Your source of information had satisfied you that you had the right party. Didn't you state at the corner of Columbus Street and the railroad track in the presence of a number of railroad men, and in the presence of the party who gave you the information, Nettie Aiken…"

Brennan jumped in immediately, visibly frustrated, "I never spoke to Nettie Aiken in my life on Columbus and the railroad track."

Mathews insisted, "Did you ever state you already had the proper party?"

Brennan, knowing he was cornered, responded, "I might have."

Mathews turned to the notion that the reward dictated the outcome of the investigation. "How much reward was offered?"

Brennan shrugged his shoulders. "I don't know. That had no effect on me."

Mathews repeated the question. "How much was offered?"

Brennan again said, "I don't know."

Mathews obviously knew better. He was well aware that potential rewards captured the full attention of policemen working a case, particularly privately funded rewards, which were commonly paid to police officers by citizens uniquely interested in a case. He pressed Brennan by asking, "Do you know that the governor offered $100?"

Brennan answered, "I remember reading that in the paper."

"Do you know that the mayor offered $250?"

Brennan admitted, "I read it in the paper."

Knowing this final piece was the reward that would interest Brennan and others the most, Mathews asked, "Do you know the Israelites offered $500?"

Brennan replied, "I heard it, but I don't think it was so."

Mathews wanted to set Brennan off, and he succeeded. "As a matter of fact, $850 or $1,000 is no inspiration to a detective trying to work out a case?"

Brennan angrily responded, "The detectives don't expect to get one dollar!"

Mathews acknowledged, "That is a very noble position to take, but do they follow that?"

Brennan asserted, "They do."

"And you have never been the recipient of any reward?"

Brennan was evasive. "Not offered by the city."

"But by private parties you have?"

"In the case of an escaped convict we are allowed to take it," Brennan admitted.

Satisfied that he had established a strong motive for the detectives to solve the case, Mathews moved on to other issues.

"Can you form any conception of what net of circumstances would have surrounded Jones and James if Duncan had never appeared on the scene?"

Brennan conceded, "I suppose we might have thought we had them until after the examination. Of course we would have to produce the witnesses before the magistrate at the preliminary examination."

Mathews, feigning surprise, asked, "There have been ten, eleven or twelve witnesses examined by the state and you are the first witness who testified that Duncan made a confession?"

Brennan corrected himself, "I didn't say he made a confession."

Mathews repeated, "You said he made certain statements to you… admissions?"

Brennan tried to explain. "I didn't use the word admission. I said when he was in the police station, when we found these invitations, he said he was going to get married, and we asked him if he had any more and he said yes, in his coat pocket. I asked him where his coat was; he said he left it in Lubelsky's store, said, 'I intended to buy some clothes and someone knocked her in the head and I got scared and run out and left my coat.'"

Mathews turned to the hat and coat. "Where did you first hear about that coat?"

Brennan said, "I heard that Abe Price had found a coat."

Mathews asked Brennan, "What does he do?"

Brennan answered, "He keeps a store. He is now running the same store that Lubelsky had."

"That was long after the assault on Mrs. Lubelsky?"

"Four or five days afterwards."

Mathews understood the importance of the point. "And yet it was four or five days before you heard that that coat had been in Lubelsky's store."

Brennan could only say, "Yes."

Mathews was not satisfied. "Have you any idea how many people, whether gentiles or Israelites, followed the officer the day that Duncan was arrested?"

Brennan could not say. "No sir, I was not there."

"Was not there a tremendous crowd?"

A Question of Speech

Brennan repeated, "I was not there."

Mathews turned to another line of questions. "Did you ever ask Duncan who arrested him?"

Brennan responded, "No, we heard that."

"Who arrested him?"

"We heard it was Needle and Goodman. That is what I heard."

"And you don't know how large a crowd was there?"

Brennan was angered again. "I don't know. I presume there was a good crowd."

Mathews then suggested that perhaps Brennan had discussed the case ahead of time with the witnesses. "You have a great deal to say to the witnesses?"

Brennan insisted, "No, not except at the police station."

"Did you ever talk to Frost?"

"Not until he was in the police station," Brennan replied.

Mathews wanted a straight answer. "Did you ever ask him for a description of the man?"

"He gave me that himself."

Mathews was now ready to bait Brennan as he had the others. "Did he ever mention any striking characteristic by which you could identify the man?"

"No."

Mathews asked the question again for emphasis. "So there was no striking circumstance brought to the attention of the department?"

Brennan again answered, "No."

Mathews moved on to the identification of Duncan at the police station, knowing that Duncan was the only man in the lineup dressed exactly to the description provided by Karesh and the black drayman the day of the murder.

Mathews asked, "When you had these other men in charge, you say men were brought down to identify them. Were these men rigged up with a blue coat and a stiff hat?"

Brennan answered, "No, they were just brought in."

Mathews followed, "But when the detectives got ready for an identification, they did garb Duncan up in a hat and blue coat?"

Brennan became evasive. "Not as I know of. I was not present all the time."

Exasperated by Brennan's stonewalling, Mathews let it go and took his seat.

Feeling that Mathews had raised several uncomfortable issues, Peurifoy opted to shore up the one point he could. He asked Brennan, "Counsel

asked you about some conversation you had with Nettie Aiken on some street where you stated you had gotten the right party. Did you ever tell anyone that you had gotten the right party until this man Duncan was arrested?"

Brennan reluctantly conceded, "I may have said I thought I had the right party, but about swearing I had the right party or committing anyone to jail as being the right party, that is not the case."

In the prosecutor's parade of witnesses, Ida Gantt, a resident of the same tenement as Duncan, was called to the stand. Her testimony focused on the clothes recovered at the tenement on Vanderhorst Street.

Next, the prosecution called John Shuller to the stand. Shuller testified that he saw Duncan in Lubelsky's store the day of the June 21 murder. "I know him by sight, I don't know his name," he said. Responding to Peurifoy's questions, Shuller claimed that he saw Duncan "leaning on the counter with his hand in his hip pocket…about half-past nine."

Mathews cross-examined Shuller, asking, "What were you doing in there, old man?"

"I always go in there talking to Max, first one thing and then another," Shuller claimed.

"Where is Collins Court?"

"Off from King Street."

"You live up there?" Mathews asked.

"Yes, sir, seven years."

"You say you knew Duncan?"

Shuller recalled, "I knew his face, but I didn't know his name. I saw him on the street off and on."

"You saw him in the store that morning?"

"He was all the time in there, off and on."

"Was he having any talk with Lubelsky?"

Shuller was nonchalant. "They were laughing and joking about the fight this man had that time."

"What man?"

"Jack Johnson."

Jack Johnson, nicknamed the "Galveston Giant," was the first black Heavyweight Champion of the World, a title he earned in 1908. Boxing fans throughout the country were looking forward to a title fight against James J. Jeffries, scheduled for July 8 and billed as the "Fight of the Century."

Mathews turned to the issue of the weapon seen by Karesh. "Did he have any stick with him then?"

"He didn't have any stick at all. He was leaning on the counter with his hand in his hip pocket. He never had any stick like that."

A Question of Speech

Shuller's testimony called most of Karesh's statements into question. No stick, but lots of laughter and joking.

Next Peurifoy called Detective James Hogan to the stand. Hogan described the crime scene on the day of the murder just as the other police officers had done. He also discussed going with John Hogan and Levy to Duncan's apartment after his arrest and seizing the clothes and jewelry believed to be stolen.

Mathews, on cross-examination, grilled Hogan about Karesh's identification of Duncan in the lineup at the jail, asking, "When Duncan was stood up with these other men, that coat and hat were put on him?"

Hogan responded, "I think so."

Mathews pushed Hogan in a tense exchange of questions and answers, starting with: "Do you know whether he got pretty rough treatment when he was arrested?"

Hogan said, "I do not, I was not there."

"And from the time that Lubelsky was killed until the time that Mrs. Lubelsky was assaulted, and four or five days afterwards, that coat remained in the store?"

Hogan was unsure. "I don't think so."

"Where had it been?"

"I think Duncan wore that coat and took it off the day that he assaulted Mrs. Lubelsky and left it in the store."

"The day that you heard he assaulted Mrs. Lubelsky?" Mathews clarified.

"Yes, sir."

Mathews felt it was now time to make his move. He pushed Hogan. "Don't you know, and know as well as I do, that when he was arrested, he was standing with one foot in the street and one foot on the sidewalk, about six or eight feet from the Lubelsky store, with his back to the east side of King Street [thus facing the store]?"

Hogan flashed with rage. "I don't know any such thing, and I don't think you know it either."

Mathews wouldn't stop. "You do know that that clothing, this clothing, that hat, has been in the charge of the detective force of Charleston and Lubelsky's friends since the time of the alleged assault?"

Hogan almost spat out his words. "I know no such thing. That stuff has been in charge of Magistrate Williams, we left these things with Magistrate Williams."

Mathews countered, "It was four days after the assault before it got to Magistrate Williams?

Hogan growled, "I beg your pardon, it was brought the very next day afterwards."

"Then Mr. Brennan was in error when he says it was on Saturday, the fourth day?"

Hogan wiped his brow. "I don't know what Mr. Brennan says, but the preliminary took place on Saturday the following day."

Mathews continued, "Mrs. Lubelsky was assaulted on Friday?"

"Yes, sir."

"What day of the week was Max Lubelsky killed?"

"On Tuesday," Hogan answered.

"Now, when was the blue coat found?"

"That blue coat was found some time after the assault on Mrs. Lubelsky. That is when it was given to me."

"Where has it been ever since?"

Hogan was consistent in his answers. "From the time it was given to me until it was brought to court it was in a locker at the police station."

"It has been in your charge?"

"Yes, sir."

Mathews concluded by, once again, probing about the issue of the large reward.

Peurifoy chose to respond to Mathews's probing questions. He asked Hogan, "And because of this reward having been offered, counsel intimates that you are manufacturing evidence?"

Hogan boldly asserted, "I defy counsel or anyone else to state that me or any one of our officers ever expressed a desire for the reward."

Jacob Needle, a tailor, was then put on the stand to testify about the clothes found at Duncan's apartment.

Peurifoy looked at Needle. "You are in the clothing business?"

"I am."

"How long have you been in the clothing business?"

"About twenty years."

Peurifoy then asked, "Were you requested to go to Lubelsky's store to see if some clothes corresponded with those in the store?"

"I was."

"Did you examine the clothes handed you and did they correspond?"

"I did and they do."

"You are sure?"

Needle was specific. "I am positive because I examined them very closely."

Mathews challenged Needle's opinion that the clothes could only come from Lubelsky's store. "Would it be difficult without some particular mark or maker's name on the garment to identify clothes?"

A Question of Speech

Begrudgingly, Needle admitted, "It would."

The next witness was Abe Price, the merchant who bought the store and inventory from Mrs. Lubelsky. He testified that when he took inventory of the clothing in the store, he found an older coat amongst the new clothes and it had Duncan's wedding invitations in the pocket. He stated that he gave the coat to Detective Hogan the next time he passed by the store. On cross-examination, Mathews established that the coat identified as belonging to Duncan was turned over to the police four days after the attack on Rose Lubelsky.

Abe Rubin, a salesman with Banov and Volaski, testified that the clothes seized from Duncan's tenement did not come from his store and Duncan had no account with them. Mathews had no questions for Rubin.

George Naylor, an awning maker who lived on Sumter Street, testified that he saw Duncan coming out of the Lubelsky store at 10:30 a.m. on the day that Mrs. Lubelsky was attacked. Mathews objected on the grounds of lack of relevance, but the objection was, once again, overruled.

Continuing, Naylor stated, "On the eighth of July, between ten and eleven o'clock, I was going up King Street and at Mr. Karesh's store I saw a lady backing out of the store next to his. She was screaming and hallooing, her hair was disheveled. About a minute and a half afterwards, I saw this man coming out. He came out and he side-stepped a couple of steps between Mrs. Lubelsky and the building."

In responding to Peurifoy's question as to the certainty of his identification, Naylor responded, "Yes sir, I am sure, I never lost sight of him but half a second when he went into the Chinaman's [laundry]. After he got in there, Mr. Needle and Mr. Goodwin, they came in. We took him from there to the sidewalk and from the sidewalk to the street. After coming on the street, Mr. Goodwin asked him why he struck the woman. He denied it, said he was in there but 'a friend of mine hit her' and went up the street. It got a little impertinent, Mr. Goodwin told him not to give him any cheek or he would smash him in the mouth. Afterwards, he did smash him in the mouth and they were hitting him until he was given to the police."

On cross-examination, Mathews established that Naylor was there as Duncan was grabbed. "You could hear him distinctly?"

"Undoubtedly," responded Naylor. "I was right alongside of him."

Finally, the long-awaited moment for the courtroom watchers arrived as Solicitor Peurifoy called Mrs. Rose Lubelsky to the stand. The tension was high as Peurifoy opened with questions about her notification about her husband's death. She noted that on June 21, she and her son were visiting family in New York when she received a telegram that her husband had

been killed. She then testified that many of the items, including a pin and a watch chain, found in the jewelry box recovered at Duncan's tenement were from their store.

Peurifoy asked the widow, "Did you see this man before?" (Pointing to Duncan.)

She paused to gather herself and responded, "As soon as I came back I buried my husband. I didn't care for myself, I tried to keep up for my little boy, so I opened the store, and as soon as I opened the store that fellow (indicating Duncan) used to come in all the time."

Leaving no doubt, Peurifoy asked, "Are you sure he is the one?"

Lubelsky responded, "I am as sure as I am sitting here that he is the devil."

Peurifoy then turned his questions to the attack on July 8. "Now Mrs. Lubelsky, you remember the eighth of July."

Lubelsky answered, "Yes sir, he opened my head. I have a mark right here."

"What did he hit you with?"

Lubelsky did not answer the question. Instead she rambled on. "While I was fixing a bundle and waiting for the eight dollars, and when I was waiting for the change I was talking about my troubles. My husband was so young…"

Mathews was on his feet in a second, objecting on the grounds that this testimony was irrelevant. Judge Watts agreed that while she could testify about events on July 8, she should not venture into her husband's death.

Peurifoy returned to his question. "Now, Mrs. Lubelsky, what became of this man after he struck you?"

Lubelsky did not answer this question either. "While I was waiting for the eight dollars, I lifted up my eyes and he struck me."

Peurifoy could see that Mrs. Lubelsky was having a hard time. Again, he asked, "Where did he go after he struck you?"

"As soon as I got struck I don't know what happened to me."

Peurifoy implored her for the third time, "Where did he go?"

Lubelsky, now crying loudly, responded, "I didn't see anything. I wished he would kill me."

"Where did you go?"

Lubelsky struggled, "I tried to run to the front and he opened his eyes so big I thought he was going to tear me in pieces and I got to the front and he got off."

Mathews stood again and objected to all testimony about July 8 since Duncan was not on trial for any crime related to that attack. Judge Watts

overruled the objection, stating, "She has a right to tell whether she saw him on that day and she has a right to state that he struck her."

After the judge's ruling, Peurifoy ended by announcing, "The state rests."

CHAPTER 8

And Nothing But the Truth

As Peurifoy took his seat, Mathews stood slowly, looked around the room and called his first witness to the stand—the defendant, Daniel Duncan. Other than watching him sit without expression, motion or word for the last one and a half days in the prisoner's dock, for many observers in the courtroom this was their first opportunity to hear from Duncan. The courtroom was silent as Duncan shuffled in his cuffs and leg irons to take the witness chair.

Defense counsel moved in front of the defendant and started with a simple question, "Duncan, how old are you?"

Shocking the entire courtroom, save the attorneys and detectives, in an instant, everyone from judge to juror understood Mathews's earlier questions, asking if witnesses had noted anything distinctive about Duncan when they spoke to him. It was a long minute before the defendant was able to stutter and stumble through a simple response: "Twenty-four years old."

It was clear to everyone that this young black man had a severe speech impediment. Mathews had only learned of it shortly before the trial when he heard Duncan trying to communicate with the deputies who brought him to court. Save this one, all-important fact, neither Mathews nor his assistant knew much at all about Duncan, since they had never even met with him prior to the trial.

The courtroom was immediately abuzz with conversation about the incredible development, and word quickly spread into the hallway and onto the street. Judge Watts called the court to order and instructed Mathews to proceed.

Mathews moved right to the events of July 8. "Now Duncan, you have heard the statements that have been made by a number of witnesses that you were up King Street near Reid and in the neighborhood of Mr. Lubelsky's

store when you were arrested. Were you up King Street?"

Duncan struggled with his speech, answering, "When I was arrested I was by Mr. Jacob's [store] on the left-hand side going up."

Mathews kept his questions simple. "Who arrested you?"

"That same officer, Mr. Stender."

"Was there anyone else around when you were arrested?"

"Yes sir, three of them. I can show you if you want me to."

"White men?" Mathews asked.

"Yes sir."

"Did they strike you?"

"Yes sir."

"How did you come to be in the neighborhood of Lubelsky's store?"

Duncan's version took some time. It was a simple response delivered in a thick Gullah accent—pronouncing *t* was no easier than *y* or *w*. "That morning I was standing up by Mr. Jacob's. I was looking in the window and about ten thirty I heard this lady halloo across the street and I went across there and saw a fellow come running out and that same woman and a gentleman in the shop next door ran out and caught me."

Mathews was confident in his client's sincerity, and he moved on to the issue of the clothing. "Did you ever buy any clothes from Mr. Lubelsky?"

"No sir."

Mathews asked about the goods seized from his home. "Did you have any clothes or any jewelry at your house?"

Duncan answered, "All I had there was four scarf pins. I bought them from Kirby."

"Did you have any clothes at your house?"

"Yes sir."

"How many suits of clothes did you have?"

Duncan kept his answer short. "Two."

"Where did you get these clothes from?"

"One came from Brown and one came from Banov and Volaski. That black coat and vest and a pair of pants."

"How did you pay for these clothes?"

Duncan proudly responded, "On time, one dollar a week."

"Would they deliver the clothes to you before you paid for it?"

"No sir."

"When you would go in there and pay one dollar, would they give you a receipt for it?"

"Yes sir."

"Where are these receipts?"

"At home."

Had Mathews had an opportunity to discuss the defense with his client, he would have seen to it that the receipts were introduced into evidence. Given the way business was done between prosecutors and defense attorneys in Charleston at the time, especially counsel for black defendants, Mathews had to be glad for the one ace he had kept up his sleeve.

Mathews asked a series of questions about his work as a baker and his thirteen-year tenure working for Geilfuss Bakery. Duncan also testified that, at the time he was grabbed by the men on July 8, they talked about hanging him before the police officer arrived.

Mathews knew his next question was going to be hard for Duncan. "Did you expect to be married?"

Duncan remained silent for a while. Then he managed, "Yes sir."

"When were you going to be married?"

"On the fifteenth of July."

"Did you buy furniture preparatory to that occasion?"

Duncan again answered with a sense of pride. "I bought a set from A.G. Rhodes."

"How much did you pay for it?"

"Five dollars."

"Buy anything else?"

"Bought a parlor set."

"How much did you pay for that?"

"Twenty-four dollars."

Mathews knew that Peurifoy would suggest that the money had come from Lubelsky's, so he asked, "Where did you get that money?"

"That is money I saved up," Duncan answered.

"You had been working right along for thirteen years?"

Duncan nodded. "Yes sir."

Mathews wanted to rebut the testimony of several witnesses, who said they had seen Duncan in Lubelsky's on previous occasions. "When was the first time you saw that lady?" (Pointing to Mrs. Lubelsky.)

Duncan answered, "That morning she was on King Street hallooing."

Mathews took his seat, concerned about how his client would hold up under cross-examination.

As Peurifoy rose for the cross-examination, he aggressively peppered Duncan with more than 150 questions, covering his work schedule, his residence, whether he was familiar with the Lubelsky store and the circumstances surrounding his arrest. Throughout the intense questioning, Duncan remained true to his initial testimony with Mathews.

Charleston's Trial

Duncan insisted that on July 8 he was simply walking down King Street, as was his habit, and he turned in the direction of Mrs. Lubelsky's screams just as everyone else did. Exasperated that he could not trip up this simple Negro baker, Peurifoy finally returned to his seat.

Mathews then called his second and only other witness, Mr. Rudolf Geilfuss, Duncan's employer. At the witness's request, Mathews had arranged for Geilfuss to wait in an anteroom until he was needed. Geilfuss, gravely self-conscious about his skin condition, was distraught about appearing in such a public situation, particularly where he would be the center of attention. As he entered the courtroom, Geilfuss gathered himself and proceeded to the witness stand.

Mathews established with the witness that Geilfuss Bakery had operated in Charleston since 1856. Geilfuss corroborated Duncan's testimony that he had worked at the bakery for almost fourteen years. Mathews concluded by asking, "Do you know his reputation for peace and quiet?"

"Yes, sir," was the simple answer.

"Is that reputation good or bad?"

Geilfuss simply responded, "Good."

Peurifoy had no questions for Geilfuss. As the self-conscious baker stepped down, he walked directly out of the courtroom, anxious to escape the scrutiny of the public.

CHAPTER 9
Arrest Who They Could Catch

With Geilfuss off the stand, Mathews indicated to Judge Watts that his defense was closed. Watts inquired if counsel for both sides was ready to offer closing arguments, and each indicated he was.

Peurifoy's assistant, Joseph Patla, started with the closing arguments for the prosecution. He outlined the circumstances of the case, beginning with the attack on Rose Lubelsky on July 8 and Duncan's arrest on King Street just outside the Lubelsky store. When the defendant was presented to the widow, she identified him as her attacker.

Patla reminded the jury of the clothes and jewelry recovered at the tenement on Vanderhorst Street, identified as the residence of the defendant. The items in question were identified as goods sold at the Lubelsky store.

Once in custody, Patla reminded the jury that Lubelsky's friend and next-door merchant, Charles Karesh, identified Duncan in a lineup as the man he saw loitering around their stores with a large stick on the morning of June 21. He recalled the testimony of Frank Frost, a black drayman, encountering a black man in the Lubelsky store on the morning of June 21 and identifying the defendant as that man after picking him in a lineup. Patla reminded the jury of the testimony of John Shuller, who had seen Duncan in the store talking to Max Lubelsky early on the morning of June 21, the day of the murder. Patla recalled the remarks of witness Abe Price, who found Duncan's coat in the store that had been operated by the Lubelskys.

In concluding his remarks, he reminded the jury of the emotional testimony of Rose Lubelsky, clearly identifying Duncan as "the devil" who struck her. He effectively quoted Mrs. Lubelsky in her statement: "I thought he was going to tear me in pieces." Before he took his seat, Patla eyed the jury, noting that Duncan showed no mercy in bludgeoning Max Lubelsky to his death, all for some items of cheap jewelry and a suit of clothes. He

showed no mercy for Rose Lubelsky when he returned to the scene of the first crime to attack the grieving widow two weeks later.

Mathews rose to make his closing arguments carrying a book. He first discussed the difference between direct evidence and circumstantial evidence in great detail, noting that the prosecutor's case against Duncan for the murder of Max Lubelsky had no direct evidence. He pointed out that there was no witness to the murder, and even with all the clothing seized at the defendant's home, none of it bore blood splatters from an attack. Mathews opened his book, describing it for the jury and reading multiple passages from it about men who were convicted of murder and executed for the crime based solely on circumstantial evidence, only later to be found innocent.

Mathews then dissected the prosecutor's case, pointing out the problems as he identified them. He first took up the issue of Duncan's severe speech impediment, pointing out that witnesses who claimed to have spoken to him made no such observation. Frank Frost, who testified that he spoke with Duncan in the Lubelsky store, stated there was "nothing peculiar" and "nothing about Duncan impressed him." Obviously the profound stuttering was the most distinctive thing about him. The failure of each witness to note the obvious stuttering represented a serious lack of identification.

Further, Mathews pointed out that when the police department first published the description of the suspect based on interviews with Mr. Karesh, Mr. Frost and Viola Gibbes, the description stated the suspect was mulatto. Yet the defendant was clearly black, not mulatto.

Mathews then turned to the crime scene on June 21, the day Max Lubelsky was murdered, pointing out for the jury the inconsistencies concerning the state of affairs in the store at the time Lubelsky's body was discovered. Multiple detectives testified as to the disarray in the store—clothes strewn about, money on the floor and the safe open—yet when the first person entered the crime scene, he saw no such disarray. Mathews recalled questioning Posner, who claimed he didn't notice anything out of place. Max Posner entered the store, walked all the way through the back of the store, came back in, sat down and noticed nothing unusual or in disarray in the store until he found his dying friend. He ran next door to ask for Mr. Karesh's help, who then refused. He next ran down King Street to find a police officer and returned with Officer Stender. During this time, the store was unattended. When the police arrived, they described the store as being in great disarray. Either the assailant hid in the store when Mr. Posner first entered, or this crime scene was tampered with to make it look like a robbery after Mr. Posner ran for help.

Arrest Who They Could Catch

Mathews then turned to the problems with the testimony of Charles Karesh. He thought it odd that a man who lived and worked next door to Max Lubelsky for eight years would observe a man standing outside the stores for three quarters of an hour, holding a wooden slat, confront this Negro, who said nothing and walked into the Lubelsky store, and, in turn, would do nothing to warn his friend. When asked by Mr. Posner for help, Karesh refused to leave his own store to stay with Max Lubelsky or to run for help.

Mathews pointed out for the jury the problems with witnesses' identification of Duncan. When Mr. Karesh arrived to face the lineup of men for identification, Daniel Duncan was dressed by the detectives to match the clothing described by the witness on the day of June 21. No other man in the lineup was dressed in a like manner. At the station house, Mr. Karesh identified the clothing, not Daniel Duncan. Then there was the matter of the identification by Mrs. Lubelsky. She was upset and shaken by the attack. Officer Hogan and others showed up at her back gate escorting a Negro, ensuring identification.

Mathews continued his closing, pointing out the failures of the detectives on the case. The entire case was based on clothing that could have been purchased at any number of Israelites' stores. The one piece of evidence that placed the defendant in the Lubelsky store was a coat with wedding invitations that was in the store for four to five days before anyone noticed it. Mathews suggested that the detectives, motivated in part by the large private reward offered in this case, employed techniques that were untrustworthy and inadequate.

The defense theory clearly held that Daniel Duncan would not be on trial had he not been accosted by the mob on King Street on the morning of July 8. Mathews suggested to the jury that it was a travesty that the state had charged the defendant with murder based on an alleged attack three weeks later. Prior to July 8, Daniel Duncan was not a suspect and was never considered by the police detectives. Multiple identifications placed the defendant at the Lubelsky store and the June 21 crime scene, despite the fact that he lived only several city blocks away and was never noticed before.

In closing, Mathews presented a study of the defendant, Daniel Duncan. He had no criminal record. He had been steadily employed by Mr. Rudolph Geilfuss for more than thirteen years. His employer considered Duncan to be of good character. Finally, the defendant's own testimony concerning his pending marriage portrayed Duncan as a young man with a future.

Mathews implored the jury to recognize that the state's case was poorly constructed, inadequate and based solely on circumstantial evidence.

Mathews looked at each member of the jury and asked for a verdict of not guilty.

With Mathews concluding his remarks, Peurifoy rose to rebut and sum up the arguments for the state. He noted that many witnesses directly contradicted the testimony of Duncan at every turn. His own coat, left during the attack on Mrs. Lubelsky, placed him in the store. The widow Lubelsky identified him as her attacker. Three credible witnesses placed Duncan at the Lubelsky store on the morning of June 21. Clothes recovered at Duncan's tenement matched those at the Lubelsky store. Jewelry recovered at Duncan's tenement matched those missing from the Lubelsky store. After the murder of Max Lubelsky on June 21, Duncan purchased a parlor set at a price four times that of his weekly pay.

The solicitor pronounced the case against Duncan to be strong and without a flaw. The case had been investigated by respected detectives with many years of service. Daniel Duncan was guilty, and Peurifoy was not inclined to show the defendant any mercy.

CHAPTER 10
Cheers and Sighs

After hearing arguments from both the prosecution and defense, just after 3:00 p.m., Judge Watts read his charge to the jury:

Mr. Foreman and gentlemen, the Defendant here is charged with murder, the highest offense known to our law, that is the State charges that on the 21st of June of this year in this County and in this city that he feloniously killed and murdered the deceased by striking him with a stick. You have heard the testimony in the case and that is for you entirely. If you are not satisfied beyond a reasonable doubt that the Defendant here was the man who killed the deceased then you need not proceed further in the case but write a verdict of not guilty. Unless the State satisfied you beyond a reasonable doubt that the Defendant was the man who did the killing then your duties are at an end and your verdict will be not guilty; if, however, you are satisfied beyond a reasonable doubt that the Defendant killed the deceased then you will inquire whether or not he is guilty of murder or man-slaughter because there is no plea of self-defense in the case at all. The Defendant denies the killing and it is for you to say whether or not under the facts and circumstances as detailed in evidence whether you are satisfied beyond a reasonable doubt that the Defendant did the killing or not.

Now murder is the killing of a human being aforethought either expressed or implied. It is not necessary that the malice be in the heart of the slayer for any great length of time before the commission of the act, but it must be there at the time of the killing. If it is there at the time of the killing that is sufficient. Now malice may be either expressed or implied. Expressed malice is evidenced by old grudges, antecedent threats, lying in wait, or matters of that character where a party makes up his mind to take the life of another, prepares to do it and in the pursuance of that preparation goes and commits

the act. The law says that is expressed malice, and a killing under these circumstances would be murder. Wherever a party makes up his mind to commit felony, that is to commit burglary, rape, or robbery, or anything of that sort and in pursuance with that deliberation and preparation, goes out and commits a felony and enters a man's house who resists and will not allow him to commit a felony; then a killing under circumstances of that sort is murder. The law will imply malice from any wanton, wicked, or thoughtless act such as taking life on no provocation, or any trifling provocation. Wherever a man is engaged in the commission of a known felony and he makes preparation, goes out with that intention and while he is at it he kills anyone who resists, the law implies malice from that and it would be murder.

Man-slaughter is the killing of any human being without malice in sudden heat and passion and upon sufficient legal provocation. Where a party kills another without malice in sudden heat and passion and upon sufficient legal provocation, and by sufficient legal provocation is meant where a party does something in the nature of a physical aggression upon the person of another which is calculated to arouse and inflame his passions and if he kills under circumstances of that sort, he would not be guilty of murder, but of man-slaughter.

Now there are two kinds of evidence introduced in court, one is positive evidence and the other is circumstantial evidence. By positive evidence is meant the positive testimony of an eye witness to a transaction, where a man swears positively that he saw a thing done. Circumstantial evidence is where there are no witnesses to the transaction, but where certain circumstances are relied upon to establish a particular fact. Circumstantial evidence is as good as positive evidence when properly proved. Each circumstance relied upon must be proved conclusively to the satisfaction of the jury beyond a reasonable doubt, and the chain of circumstances must be complete and must point to the guilt of the accused to the exclusion of every other reasonable hypothesis.

If you are satisfied beyond a reasonable doubt that the Defendant killed the deceased, then, as I have said before, you can find him guilty of murder or man-slaughter. If you find him guilty without a recommendation to the mercy of the court, the law fixes his punishment as death by hanging. If you find him guilty of murder and recommend him to the mercy of the court, the law fixes his punishment at life imprisonment at hard labor in the penitentiary. If you find him guilty of man-slaughter, in that case his punishment would be at the discretion of the judge, no less than two years and not more than thirty.

Cheers and Sighs

You will give the Defendant the benefit of every reasonable doubt growing out of his testimony. If you are not satisfied beyond a reasonable doubt that he killed the deceased, then you acquit him or if you think he didn't kill him then you will acquit him. If you think that he killed him, that is, if you are satisfied beyond a reasonable doubt that he killed him and that he actuated by malice under the law as I have given it to you, then you will find him guilty with or without a recommendation to the mercy of the court. If you are not satisfied that he is guilty of murder, but you are satisfied that he killed the deceased and did it in the sudden heat and passion without malice and upon a sufficient legal provocation, then you will find him guilty of man-slaughter.

The form of your verdict will be guilty…or guilty with a recommendation to the mercy of the court…or guilty of man-slaughter…or not guilty and sign your name as foreman.

Judge Watts dismissed the jurors to their room for deliberations, noting that the court would receive their verdict at any hour. The defendant was removed in shackles to a holding room under heavy guard. Some of the citizens stepped outside for fresh air, but most simply stayed in their place, not wanting to give up an ensured seat as this public trial neared a conclusion.

The wait was not long. In less than one hour the jurors sent word to the judge that they had agreed upon a verdict. It took half as much time to simply place the court officials and attorneys back in their positions and the defendant back in the dock. At 4:30 p.m., Judge Watts took his place. The clerk of court, W.H. Dunkin, called for the written verdict. Jury foreman Robert Lebby passed the small slip of paper to the constable, who, without reading it, passed the paper to the clerk.

Though this paper transfer was effected quickly, for the people in the overflowing courtroom it seemed as though the clerk, foreman and constable were moving in slow motion. Some men now stood on their benches, trying to get a better look at the defendant or the widow for the reading of the verdict. Rose Lubelsky sat motionless, gripping the arms of her chair so tightly that her knuckles were white and staring straight ahead at nothing in particular.

Sheriff Martin had a team of deputies surround the dock with Duncan inside. Though everyone felt certain of a guilty verdict, the moment felt most unpredictable. Clerk of Court Dunkin stood, opened the paper from the constable and read, "The *State v. Daniel Duncan*; indictment for murder —GUILTY, signed R.C. Lebby, foreman."

Charleston's Trial

Cheers and sighs of relief filled the courtroom. Rose Lubelsky sobbed aloud—sobs of relief; sobs of longing for her husband, whose life was cut short. The reporter for the *News and Courier* wrote, "When the word 'guilty' was pronounced, a psychological wave flashed over the courtroom like an electric current."

Before most of the excited crowd realized the defendant was gone, a throng of sheriff's deputies had spirited Duncan from the dock and out of the courtroom to a secure and well-guarded room. Amidst the turmoil, Judge Watts rapped his gavel, announcing that the court would reconvene at 10:00 a.m. on Monday morning for sentencing.

Duncan, who throughout his arrest and trial always felt that even an all-white jury would still have to recognize his innocence, sat bewildered in the holding room as Deputy Sheriff Poulnot carefully searched the prisoner before releasing him to return to the jail. Duncan was placed inside the Black Maria, which was surrounded by deputies, walking and on horseback, for the short ride back to the jail on Magazine Street.

Upon his return to the jail, Duncan was again searched by two deputies before he was placed in a solitary cell by Patrick Hanley, the jailer, following the careful instructions of Sheriff J. Elmore Martin.

That night was an emotional one in the port city. Its white citizens were greatly relieved that the trial ended with a guilty verdict. The black citizens followed the proceedings with the same intense interest, even though none dared be present at the court. Though few chose to express their opinions publicly, the city's black community believed that the mild-mannered baker's assistant was innocent.

CHAPTER 11
May God Have Mercy

Monday, October 10, 1911

Defense Counsel Mathews filed a motion for a new trial with the court first thing on the morning of the tenth. Judge Watts agreed to hear the motion before Duncan would be presented for sentencing. The convicted man was moved from the jail to the courtroom again under heavy guard and held in a private room until the motion was heard.

Mathews petitioned for a new trial based on the introduction of a bounty of evidence that had no direct bearing on the murder on June 21. Specifically, he asserted that the testimony offered by many witnesses over the alleged July 8 attack served to prejudice the jury. This voluminous testimony over the July 8 incident and capture served to convince the jury that Duncan was a guilty man, leaving little distinction between the events of June 21 and July 8.

Judge Watts did agree that some of the testimony "was on dangerous grounds," but it was his opinion that the defendant received a fair trial and justice was ultimately served with the verdict of guilty. The motion for a new trial was therefore denied.

With the issue of Mathews's motion concluded, Judge Watts ordered that Duncan be brought to the courtroom. Though there was no mystery as to the sentence that would be administered in this case, given the verdict of guilty and no mention of any recommendation of mercy to the court, the courtroom was again packed as the convicted man appeared in shackles and, under heavy armed escort, was moved into the prisoner's dock to hear his sentence.

Once Duncan was settled in the dock, the large contingent of armed deputies stayed in place surrounding him. Judge Watts read the sentence for Duncan:

Charleston's Trial

It being solemnly demanded of the prisoner at the bar if he hath anything to say why sentence of death should not be passed upon him, he saith nothing further unless as he has before said; wherefore, it is considered by the Court, and pronounced as the judgment of the law, that the said Daniel Duncan be taken hence to the place whence last he came, there to be kept in close and safe custody until Friday, the 2nd day of December next, and that on that said Friday, between the hours of 10 in the forenoon and 2 in the afternoon, he be taken to the place of execution in the county, and there be hanged by the neck until his body be dead. And may God have mercy upon his soul.

Remarkably, Duncan was as stoic for the reading of the sentence as he was for the entire trial. He showed no emotion and he offered no comment. The deputies led Duncan away, placing him again in the Black Maria to return to his solitary cell, where he would await his execution.

CHAPTER 12
JAIL BOUND

Duncan was remanded to the Charleston County Jail on Magazine Street to await his execution. The jail was a foreboding facility that had served to incarcerate prisoners for the last 110 years. As recent as February 1910, the Charleston County Grand Jury reviewed the jail and announced that the facility was inadequate, unsanitary and not secure. This massive facility was often the subject of controversy, complaint and study, but it always made a lasting impression on its occupants.

Various sites and buildings were used as a jail in Charleston's early history. An act in 1783 set aside land on Magazine Street to be used as "a gaol," though construction on a new jail would not commence for more than a decade. The jail at the time was in such deplorable condition that, in 1794, a grand jury complained to the court: "a very great grievance the dirty, filthy, and unwholesome status of the rooms in which prisoners are confined in gaol; also the yard around the same, by which means they are liable to malignant disorders which would easily be communicated to the inhabitants of the city."

In November 1802, the "Commissioners for building a Gaol in Charleston" notified the governor that the new gaol was ready for use, but the funds provided did not allow for the "erection of a Necessary, the making of a well, and building of a wall round the lot." The jail was two stories tall, with the first floor housing the jailor and his family, debtors housed in other rooms and the second floor reserved for criminals. The walls and flooring were made of oak, with a large iron ring in the floor of the cells to secure dangerous prisoners.

Sheriff Thomas Lehre complained of the jail as early as 1803, noting:

> *Great hardships are endured by Debtors and criminals, especially by the latter by being confined several together in small apartments in a loathsome*

> *Prison, particularly in Summer Season, for the want of fresh air, and exercise. In addition to the above they are compelled to answer the calls of Nature, in the very same Rooms where they eat, drink, and sleep, which in a climate like ours, creates such a stench as is enough to poison them, indeed in many instances it totally destroys the appetite. Their bodies often get so much debilitated and many of them contract such disorders from being so confined, as ever after to disqualify them when discharged from Prison, from getting a livelihood by their Labour, they then are thrown upon the world in a languid state to drag out a miserable existence.*

Despite the sheriff's pleas, the addition of a privy was not immediately approved.

The jail was not originally well constructed for security. The ceiling of the top floor was constructed of thin pine boards, and once discovered by the prisoners, it was easy to cut through. In 1805, four inmates accomplished the task of cutting through to the roof, lowering themselves to the ground and escaping. This vulnerability to escape and the constant leaks from any amount of rain finally led to the sheriff's request for repairs in 1810. Apparently in no hurry to correct the deficiencies at the jail, it was not until 1817 that the state appropriated money for repairs to the roof.

In 1822, money was provided for expansion of the jail. A third floor was added, and a new wing that was four stories tall and fireproof was built on the rear of the jail. This construction was done under the supervision of famed Charleston architect Robert Mills, who served as state architect and engineer for the Board of Public Works.

In his 1826 book, *Statistics of South Carolina*, Mills described the Charleston Jail. He wrote:

> *It is a large three story brick building, with very roomy and comfortable accommodations…A spacious court is attached to the prison, and every attention to cleanliness is paid throughout, which is highly creditable to those who have the charge of the institution. Very general good health is enjoyed by the prisoners.*

By the description alone, one might think Mills was describing the Charleston Hotel rather than the jail.

Captain Basil Hall, an Englishman, recorded his travels through North America in 1827 and 1828. His time in Charleston included a visit to the jail. In February 1828, he recorded:

Jail Bound

In the jail there were no separate sleeping berths for the prisoners, who appeared to pass their days and nights in idleness and free communication. At one part of the prison I saw several small cells for different descriptions of convicts, who, however, had no labor to perform. The jailor told me that he never put more than one white man into these places; the blacks were so thick upon him, he was obliged to put in two at a time.

In the courtyard of this jail, there were scattered about no fewer than 300 slaves, mostly brought from the county for sale, and kept there for about ten pence a day, penned up like cattle, till the next market day. On the balcony along with us, stood 3–4 slave dealers, overlooking the herd of human victims below and speculating upon the qualities of each.

Francis C. Adams, a career United States diplomat, also wrote of the Charleston Jail in his book, *Manuel Pereira: or the Sovereign Rule of South Carolina*:

The jail is a sombre-looking building, with every mark of antiquity standing boldly outlined upon its exterior. It is surrounded by a high brick-wall, and its windows are grated with double rows of bars, sufficiently strong for a modern penitentiary. Altogether, its dark gloomy appearance strikes those who approach it with the thought and association of some ancient cruelty. You enter through an iron-barred door; and on both sides of a narrow portal leading to the right are four small cells and a filthy-looking kitchen, resembling an old-fashioned smokehouse. These cells are the debtors'; and as we were passing out, after visiting a friend, a lame "mulatto-fellow," with scarcely rags to cover his nakedness, and filthy beyond description, stood at what was called the kitchen-door. "That poor dejected object," said our friend, "is the cook. He is in for misdemeanor—one of the peculiar shades of it for which a nigger is honored with the jail."

On the left side, after passing the main iron door, are the jailer's apartments. Passing through another iron door, you ascend a narrow, crooked stairs, and reach the second story; here are some eight or nine miserable cells—some large and some small—badly ventilated, and entirely destitute of any kind of furniture; and if they are badly ventilated for summer, they are equally badly provided with means to warm them in winter. In one of these rooms were nine or ten persons, when we visited it; and such was the morbid stench escaping from it; that we were compelled to put our handkerchiefs to our faces. This floor is appropriated for such crimes as assault and battery; assault and battery with intent to kill; refractory seamen; deserters; violating

the statutes; suspicion of arson and murder; witnesses; and sorts of crimes, varying from the debtor to the positive murdered, burglar and felon…

From this floor, another iron door opened, and a winding passage led into the third and upper storey, where a third iron door opened into a vestibule, on the right and left of which were grated doors secured with heavy bolts and bars. These opened into narrow portals, with dark, gloomy cells on each side. In the floor of each of these cells was a large iron ring-bolt, doubtless intended to chain refractory prisoners to; but we were informed that such prisoners were kept in close stone cells, in the yard, which were commonly occupied by negroes and those condemned to capital punishment. The ominous name of this third storey was "Mount Rascal," intended, no doubt, as significant of the class of persons it contained. It is said that genius is never idle; the floor of these cells bore some evidence of the fact in a variety of very fine specimens of carving and flourish work done with a knife. Among them was a well-executed crucifix, with the Redeemer, on Calvary—an emblem of hope, showing how the man marked the weary moments of his durance. We spoke with many of the prisoners, and heard their different stories, some of which were really painful. Their crimes were variously stated, from that of murder, arson, and picking pockets, down to the felon who had stolen a pair of shoes to cover his feet; one had stolen a pair of pantaloons, and a little boy had stolen a few door-keys. Three boys were undergoing their sentence for murder. A man of genteel appearance, who had been sentenced to three years' imprisonment, and to receive two hundred and twenty lashes in the market, at different periods, complained bitterly of the injustice of his case. Some had been flogged in the market, and were awaiting their time to be flogged again and discharged; and others were confined on suspicion, and had been kept in this close durance for more than six months, awaiting trial…

In 1853, the Charleston mayor and city council appealed to the General Assembly to remodel and expand the jail or replace the facility. In a petition, they wrote:

The present building is wholly unsuitable for the wants of the community in both size and security. It is so small that Prisoners of different grades of Crime, cannot be kept separate, and in so dilapidated a condition that even the safe custody of the prisoners cannot be relied upon.

The General Assembly did appropriate funds, and in 1855–56, the jail was altered and expanded. Charleston architects Louis J. Barbot and John

Jail Bound

H. Seyle provided the plans for the changes and supervised the work. They altered the Magazine Street façade to reflect the Italian style popular in the 1850s by adding five-story double towers on the front. They added a fourth floor to the original portion of the building, removed the 1822 Mills addition and replaced it with a four-story octagon addition. On top of the octagon addition, a two-story tower was placed. The entire building was fireproofed for safety. Though "fireproof," the jail was likely saved during the city's great fire of 1861 when General Ripley ordered the houses near the jail blown up to create a firebreak.

During the Civil War, the jail and many of the city's public buildings were used to house Union prisoners of war. Union Captain Luis F. Emilo, in his book, *A Brave Black Regiment: The History of the Fifty-Fourth Regiment of Massachusetts Volunteer Infantry, 1863–1865*, wrote, "Charleston Jail, for many months the prison of the Fifty-Fourth men, stood in about an acre of ground enclosed with a brick wall some twelve feet high…Adjoining it could be seen the Workhouse, Medical College and Roper Hospital, which were also used for the confinement of Union prisoners." According to Emilio, the surgeon attending the jail was Dr. George R.C. Todd, who claimed to be Mrs. Lincoln's brother and was described as a "profane, obscene, and brutal man."

Harper's Weekly published an engraving of the jail and workhouse in its February 18, 1865 issue. The accompanying story states:

> *In last August the jail and yard were occupied by six hundred army and navy officers, who were placed under the fire of our batteries on Morris Island. They were occupied at the same time by felons, murderers, lewd women, deserters from both armies, United States colored soldiers, and Southern slaves, most of whom were permitted to walk at will among the officers.*

A Union officer, W.S. Glazier, who was confined at the jail, described the allocation of the various offenders imprisoned with him. He wrote, "The ground-floor of the jail was occupied by civil convicts; the second story by rebel officers under punishment for military offenses; the third story by negro prisoners; and the fourth by Federal and rebel deserters."

In 1867, Union Captain H.A. Coats of the Eighty-fifth New York Infantry testified before the Congressional committee investigating the treatment of prisoners of war. He noted that he was

> *one of 400 in the yard. They had no blankets and no shelter whatsoever. There was but one privy, never cleaned out…Later, many enlisted men were brought and filled the jail-yard to overflowing. In the hall was a sutler,*

Charleston's Trial

The Charleston County Jail as it appeared in an 1865 issue of *Harper's Weekly*. The fourth floor of the jail was removed after the 1886 earthquake. On the right, in the background, is the old slave workhouse. *Author's collection.*

The workhouse on Magazine Street. This building had to be destroyed after severe damage in the 1886 earthquake. *Author's collection.*

Jail Bound

who tantalized the prisoners by a display of food held at prohibitory prices, except for a few fortunate ones.

The Charleston Jail and most buildings in Charleston were damaged by the earthquake of 1886. The workhouse, located next to the jail, was so damaged that it was eventually razed. The fourth floor and forty-foot tower over the octagon portion of the jail were removed as repairs were completed. After the earthquake repairs, the jail operated "as is" until and following Duncan's arrival.

The neighborhood surrounding the gothic structure was home to countless prostitutes, drug dealers and gamblers—the absolute irony was their coexistence right next door to the jail itself. Duncan had no interest in such things. For Charleston's blacks, one thing about the jail remained constant: it was a miserable place of lost hope.

CHAPTER 13

SOME HOPE BE MO' DEN NO HOPE

Several days after the sentencing, Buchanan Duncan, Daniel's father, arrived unannounced at Mathews's office. With his deed and paid mortgage in his hand, he asked to speak with the attorney.

Mathews reluctantly agreed to speak to his client's father. Duncan told Mathews of the property he owned on Society Street. Though the building was uninhabitable, the property was valuable. He offered the property to Mathews if he would file an appeal for his boy.

Mathews fairly explained that the prospects for an appeal to be successful were remote, but if that was what he wanted, he would proceed. Duncan simply indicated that at least some prospect for hope was better than no hope at all.

Just nine days after Judge Watts sentenced Duncan to death, Defense Counsel Brice Mathews filed a "Notice of Intention of Appeal" with the Court of General Sessions. This notice would serve to postpone the date of execution. News of the appeal shocked the community as everyone assumed that Duncan and his family had neither money nor assets to finance such a legal effort.

In an interview with the *News and Courier* at the jail, Duncan said, "I believe that my case will be carried to the Supreme Court, and when it is tried there I will be freed." He insisted that his arrest and conviction were a "put up job." Also convinced of Duncan's innocence, his sisters, brother and father continued the daily ritual of bringing hot meals to the jail for their downtrodden relative falsely accused.

In his appeal to the Supreme Court, Mathews asserted that the defendant should be granted a new trial on the following grounds:

Charleston's Trial

The verdict was contrary to the manifest weight of the evidence, in that evidence being entirely circumstantial failed to point to the defendant as the guilty party, to the exclusion of any other reasonable hypothesis.

The Presiding Judge erred in testimony as to incidents subsequent to the time laid in the Indictment, and which had no connection with the offense charged.

Though weeks slipped into months awaiting action by the Supreme Court, Duncan remained resilient and confident in his rescue by the state. Much to the chagrin of Sheriff Martin and the jail staff, he showed no signs of offering a jailhouse confession.

Only weeks after Duncan was remanded to the county jail, a familiar name appeared on the jail roster awaiting the next Court of General Sessions. William Murray, a former suspect in the murder investigation of Max Lubelsky, was arrested, once again, jumping a freight train out of Charleston.

This time Murray was apprehended in Augusta, Georgia, and sent back to Charleston, where he was charged with grand larceny. He had allegedly robbed a Jewish merchant on Market Street. Murray was escorted back to Charleston by none other than Detective Levy, who had predicted earlier that he would run into Murray again.

Duncan was living well on the daily meals supplied by his family. He frequently passed the time by swinging in his hammock and smoking cigarettes, when he had them. He would occasionally read.

For inmates, jail time was slow time, with few distractions from the daily routine other than occasional visitors. Friends or family members would frequently pass small change to the inmates to purchase cigarettes or candy. Prisoners wishing to purchase goods folded several pennies in a piece of paper. The paper would be passed cell to cell until it reached the prisoner nearest the small window in the room. The weight of the pennies held by the paper allowed it to be tossed out the window to a boy waiting outside.

Keeping one penny for his trouble, the boy would purchase two "penny cigarettes" or two pieces of candy at the corner store on Queen Street, wrap them in the paper and toss the contraband back through the window. Smoking cigarettes, referred to by prisoners as "coffin nails," was the primary way to pass time.

Without the guiding hand of a mother in the family and a father who worked long hours, Duncan and his siblings grew up without the religious instruction common in Charleston's black families. Duncan's first exposure to religion may well have been in the person of Obadiah Dugan, the founder

Some Hope Be Mo' Den No Hope

Reverend Obadiah Dugan with the Star Gospel Mission, accompanied by his portable organ, conducted services every Sunday morning at the Charleston Jail, circa 1910. *Courtesy of the Star Gospel Mission.*

Reverend L. Ruffin Nichols, pastor of Morris Brown AME Church. *Courtesy of Emanuel AME Church.*

of the Star Gospel Mission. Dugan founded the mission in 1904, after his religious conversion following a life of heavy drinking, rendering him dedicated to saving the many wayward souls in Charleston.

Dugan provided shelter for needy men in the city, offering daily services and testimony for any who would attend. Each Sunday morning, he would transport his portable organ to the jail and offer spirited services for the men and women incarcerated there. After a full morning at the jail, Dugan loaded his organ on the mission's wagon and spent Sunday afternoon holding services on the streets of Charleston.

Dugan, knowing of Duncan's sentence to die, always stopped by the third floor cell to offer comfort and guidance to the condemned man. Reading from his prayer book, the street preacher sought to give Duncan some assurance that his sins were already forgiven and he could take some solace in knowing his fate.

In addition to Dugan's enthusiastic jailhouse services, Duncan was visited by Reverend Louis R. Nichols, pastor of the Morris Brown AME Church. With the Duncan trial and conviction holding the full attention of both white and black Charleston, Nichols elected to minister to the convicted man to ensure what comfort he could provide given what Nichols saw as the judicial atrocities committed against him. Though not sure of the religious comforts offered by the good reverend, Duncan was glad for another visitor who also believed in his innocence.

Even as conditions at the jail seemed, at times, inhuman, Captain Handley, with permission of the sheriff and help of the Star Gospel Mission, sought to ease the pain of the prisoners on special occasions such as Thanksgiving Day. On their assurance of proper behavior, the prisoners were allowed to leave their cells for the one day. Deviating from the normal fare of three meals of salted meat, hominy and corn bread, the day started with a breakfast of eggs, bacon, sausage and ham. Bags of fruit and nuts, donated by Reverend Dugan, were distributed to the prisoners. At 2:00 p.m., the traditional Thanksgiving Day feast, complete with soup "a la Goose Creek," Blue Point oysters, rice, turkey, cranberry sauce, corn on the cob and an old English "plum duff" dessert, was enjoyed by all.

Christmas was again an opportunity for holiday celebration at the jail. All the prisoners, Duncan included, enjoyed a feast of roast beef, gravy, rice and pudding. Baskets of fruit and cakes were donated to the jail by various groups in Charleston to aid in a festive yuletide celebration.

CHAPTER 14
NOWHERE TO TURN

In February's term of general sessions court, William Murray appeared and pled guilty to the charge of grand larceny. He was sentenced to twenty months hard labor.

Murray was one of thousands of prisoners who passed through the county jail en route to trial, the chain gang or the state penitentiary each year. They shuffled in and out, depending on the length of sentence and whether or not they were chain gang material. There was only one prisoner whose status had remained constant for the entire year—that was Daniel Duncan.

On March 27, 1911, the South Carolina Supreme Court denied Duncan's appeal. The opinion, written by Associate Justice Eugene B. Gary, noted:

> *Similar testimony, tending to show that the defendant committed an assault upon Mrs. Lubelsky, was introduced without objection.*
>
> *The testimony tends to show that the defendant had a motive in killing Mrs. Lubelsky. He testified that he did not know where Max Lubelsky's store was, yet there was testimony to the effect he was in the same store time and again and entered into friendly conversation with the deceased. Mrs. Lubelsky was aware of this fact; and, he may have supposed, that if her lips were sealed in death, no one could contradict his testimony, in this respect.*
>
> *It is the judgment of this court, that the judgment of the court be affirmed, and that the case be remanded to that court, for the purpose of having another day assigned for the execution of the sentence.*

The Court of General Sessions, pleased with the affirmation of the original verdict, reset the date of Duncan's execution for July 7, 1911, between the hours of 10:00 a.m. and 2:00 p.m.

Charleston's Trial

Duncan was upset with the Supreme Court's refusal to set a new trial, though he never showed any such emotion to the other prisoners or the jailors. During the last week of June, the condemned prisoner was put on a suicide watch. A jail trustee watched over Duncan by day, and a sheriff's deputy kept watch by night.

Attorney Brice Mathews made a late appeal for Governor Blease to commute the death sentence by again stating that the case against Duncan was only circumstantial, and many doubted Duncan's guilt. Blease contacted both the prosecutor Peurifoy and Judge Watts, who presided over the trial. Both men assured the governor that they had no doubt about Duncan's guilt. Known through the state for his pronounced racist views, Blease, an avid supporter of Jim Crow legislation, was not the kind to show much sympathy to blacks.

Reverend M.M. Monson delivered a plea to the governor for the black ministers and priests of Charleston on Duncan's behalf. Blease responded to all parties that he would not interfere with the prisoner's execution.

The Duncan family never tired in their meal deliveries to the jail. After the Supreme Court's refusal and the governor's announcement that he would not interfere, Buchanan Duncan and his other children grew tense and depressed, finding it difficult to face Daniel with any optimism. Their condemned son and brother, however, never showed any panic or anger. As his options for legal redemption disappeared, he found solace in the redemption provided by God, as introduced by Reverend Nichols.

CHAPTER 15
REDEMPTION

With the date for the execution nearing, Reverend Nichols began visiting Duncan daily. With Duncan still in his cell and Nichols sitting just on the outside of the bars, Duncan listened intently as the AME pastor read from the Bible. Each visit began and ended with a prayer.

Just a week before the scheduled hanging, Duncan declared that he wanted to enter heaven as an official member of the AME Church. Nichols contacted Sheriff Martin to seek permission for a jailhouse baptism, as requested by Duncan. Martin granted permission on the caveat that the condemned man could not leave his cell. Nichols, assisted by five other black pastors, conducted the solemn ritual, assuring Duncan of his place in eternity. Nichols accomplished his task by providing a means for Duncan to face his fate with some acceptance.

Independence Day, like Thanksgiving and Christmas, was a day of celebration, even at the Charleston Jail. The prisoners were allowed out of their cells to join in a holiday dinner provided by several local churches and the Star Gospel Mission. Duncan was allowed to participate, though he was watched closely by the guards.

Other than the jail staff and ministers, the only person to speak to Duncan was Lofton Hansley, a fellow prisoner awaiting trial for murder. Hansley and Duncan were enjoying a breakfast feast of eggs, grits and sausage when they first heard the band. The famous Jenkins Orphanage band played in several community parades each year. With the orphanage next door to the jail, the prisoners could enjoy the band of Negro children warming up and practicing their musical numbers before they left for the Independence Day parade. For a brief moment in time, the two men, with toes tapping and a feast before them, enjoyed the day without thinking about Duncan's date with the executioner.

Charleston's Trial

On July 5, just two days prior to his hanging, Duncan granted an interview to a reporter with the *News and Courier*. Sitting in his hammock within the confines of the cell, the condemned man chatted with the reporter for twenty minutes, never showing anything but a calm demeanor.

Duncan shared the story of his life and explained that he quit school at the age of ten and took a job with Geilfuss Bakery just after the death of his mother. He recalled that his starting pay as a young boy still in short pants was seventy-five cents per week. He laughingly shared that, though he sometimes ended the day with more flour on him than in the bread, Mr. Geilfuss continued to train him and promote him. At the time of his arrest, something that he had never faced before, he had completed thirteen years working at the German bakery.

In closing, Duncan said to the reporter:

> *When a man makes up his mind to undergo a thing he can do it, if he has faith. I am a member of the church now, and feel that I will meet my maker tomorrow. I go to Him with a clear conscience, and often I have thought that I would be glad when the day came, for I believe that my soul will be saved.*

During the short interview, Duncan constantly stuttered while responding. At one point, when asked his age, it took several minutes for Duncan to respond with the simple answer of "twenty-four." This speech impediment was a considerable point of interest in the trial. The reporter pondered how the several witnesses who claimed to have spoken to Duncan on June 21, the day of the murder, could have missed this obvious problem.

When the Duncan family brought the evening meal after the reporter left, Captain Hanley notified them that Duncan would have to consume only jail meals for his last two days. He did state to Duncan and his family that he could choose his menu for these last meals.

As the morning of July 6 arrived, Duncan consumed his first breakfast prepared by the jail, a meal of eggs, bread and milk. He passed the morning reading passages in the prayer book left by Reverend Nichols.

In the July 6 edition of the *News and Courier*, the reporter wrote of his meeting with Duncan on the previous day. He noted Duncan's insistent claim of his innocence. The reporter allowed that the case against Duncan was circumstantial and that, given the reputed good character of the young black man, an increasing number of people were questioning Duncan's guilt. However, he also noted that a jury of twelve men believed Duncan to be guilty, an opinion in which Judge Watts, Solicitor Peurifoy and Governor

REDEMPTION

PRICE FIVE CENTS

DUNCAN TO HANG HERE TOMORROW

Governor Refuses to Interfere in Behalf of Condemned Negro

STICKS TO CLAIM OF HIS INNOCENCE

Interviewed in Cell, Negro Repeats That He Did Not Murder Lubelsky

Headlines in the *Charleston Evening Post*, July 6, 1911. *Courtesy of the Charleston County Public Library.*

THE CHARLESTON EVEN[ING]

MANY APPLYING TO SEE HANGING

Sheriff Martin Does Not Intend to Permit Crowd in County Jailyard

DANIEL DUNCAN TO PERISH ON FRIDAY

Lubelsky's Murderer Takes Religious Consolation and Makes Ready

Headlines in the *Charleston Evening Post*, July 5, 1911. *Courtesy of the Charleston County Public Library.*

Charleston's Trial

Blease concurred. The reporter concluded, "Duncan, the only man who actually knows whether his hand is stained with the blood of Max Lubelsky, refuses to make a confession, and looking at the gallows upon which he will hang, declares his conscience clean."

The jail staff had a busy morning checking, testing and preparing for the next day's events. Sheriff Martin held a meeting with the jailors and his deputies in the jail yard, reviewing the order of events for the next day. Just as he announced to the newspaper, he only divulged to his deputies that the hanging would take place between 10:00 a.m. and 2:00 p.m., the same time window provided in the court order. Knowing that a good bribe could open the tightest lips, Martin was determined that his men could not tell what they did not know.

Martin had already announced that the jail yard would not be opened to the public on the day of the hanging. Nevertheless, following the procedure for previous hangings, several hundred people applied for the permit to attend the execution. They were all denied.

The new, one-inch hemp rope that would serve as the noose was being stretched with one end tied to a weighted rack, while the other end was secured to the five-hundred-pound lead weight that would propel the condemned man to his death. The pulley and the lever serving as the trigger for the weight were checked and rechecked.

Reverend Nichols made his daily visit to the jail with an entourage of other ministers in the early afternoon, offering prayers and a message of salvation. To a man, the ministers admitted that Duncan appeared much more at ease than any of them during the visit. As they bade him goodbye, no one looked forward to their return the next day to witness the hanging. Sheriff Martin had already notified everyone that the only people from the black community to be allowed at the jail for the hanging would be the ministers. Duncan's own family would be excluded, in Martin's opinion, as much for their own safety as to spare them the need to witness the execution of their loved one.

Duncan ordered steak for his 2:00 p.m. dinner. As he enjoyed the tender beef sitting in his hammock, he could stretch enough to see the jailors still testing and retesting the gallows mechanism. As the sun began to fade, darkness enveloped the large jail room containing the small cells. The trustee was replaced by the white deputy, who turned the gas lamp to shine on Duncan for the night while he maintained the suicide watch. Duncan turned in his hammock so the light illuminated his reading. He finally drifted off to sleep, his prayer book still in his hands.

CHAPTER 16
SNATCHED…TO RETURN A CORPSE

Charleston, like any city, has a long history of crime and punishment. The city newspapers kept readers' rapt attention by publishing detailed accounts of crimes, from pickpockets and swindles to murders. Of course, what followed was the coverage of the trials. Nothing aroused the morbid curiosity of the readership more than a murder trial and the prospect of a public hanging.

South Carolina led the Southern states through history in the number of crimes punishable by execution. In 1813, there were an astonishing 165 different crimes for which the punishment, if convicted, could be death by hanging. By the early twentieth century, the number had been reduced to 6 specific crimes.

Executions were open to the public, as popular thinking was that the horrific spectacle might serve as a deterrent to crime. Truthfully, most often the sheriff simply yielded to the public's insatiable appetite for witnessing these gruesome events. In Charleston, only Race Week, the annual thoroughbred races held the first week in February, turned out a bigger crowd than a hanging. The events were well advertised in the newspaper and through street pamphlets. The day of a hanging, to the uninitiated, might appear to be more of a carnival than an execution. Street vendors turned out selling all sorts of foods and box lunches. Writers hawked programs with their own version of the gruesome crime and a sketch of the life of the condemned man (or woman). Spectators arrived early to gain the best vantage point.

By the early nineteenth century, executions were generally carried out in one of three locations: on Boundary Street, later renamed Calhoun Street; "on the lines," a reference to a site on the old fortifications built for the War of 1812, named Line Street; and in the yard of the county jail on Magazine Street.

Charleston's Trial

While executions were frequent, they were not necessarily carried out skillfully. Such was the case for the hanging of Joshua Nettles in 1805. The art of a good hanging is to place the noose around the neck of the condemned prisoner so that as the prisoner is dropped, the fall snaps his neck and death is instantaneous. On February 8, 1805, the executioner did not place the noose tightly around Nettles's neck. When he was dropped, the rope slid around his face. The *Charleston Courier* reported the gruesome event that followed: "With a vigor of mind and body that astonished us, he [Nettles] broke loose his arm, lifted himself by the rope, brought it to his left ear, then dropped his hand, and underwent the punishment with scarcely a struggle."

Though many articles written and legends told boast that there has never been an escape from the Charleston County Jail, such a prideful record could not be further from the truth. Martin Toohey, convicted for the murder of J.W. Gadsden, was one such prisoner who did escape, albeit with the help of a jailer. Two brothers of Toohey successfully bribed a guard, who was to receive $600 and two watches once the escape was complete.

Toohey, however, was captured once again and returned to the jail to await his execution, which occurred in the jail yard on May 28, 1819. After receiving the signal from the sheriff, the hangman released the trapdoor, dropping Toohey to his death. The *Charleston Courier* reported that, after hanging for twenty-five minutes, the body was cut down and given to his friends and family, who were allowed to attend. The reporter noted, "Some attempts were made to resuscitate it, but the *vital spark* had fled, the blood congealed in his veins, and his 'mortal had put on immortality.'"

In the same month as the Toohey hanging, Charleston bore witness to one of its most infamous trials—that of John and Lavinia Fisher. This brutal couple was arrested for highway robbery and murder of multiple guests at their inn outside of Charleston, called the Six Mile House. They were convicted of highway robbery in May, but their attorney appealed the case to the Constitutional Court.

The Constitutional Court upheld the conviction on January 17, 1820, condemning them to hang on February 4. Governor John Geddes allowed a two-week postponement to the execution to allow the Fishers "time to meet their God." Geddes, though, was indifferent to the letters and petitions from Charleston ladies asserting that it was improper for a white woman to be executed.

The job of executioner in Charleston was not a popular one. The sheriff often corralled the town drunk and incarcerated him to sober him up enough to pull the executioner's lever. John Blake White, noted Charleston attorney, writer and artist, wrote of his visit to the jail and meeting the executioner for

Snatched...To Return a Corpse

John and Lavinia Fisher.

> *We followed the jailor to another cell, at a remote corner of the building. After repeated calls, a voice at length answered from within, as from a sepulcher. The door being unbarred and opened, we beheld, stretched upon the floor, a being that appeared to be anything rather than a human. Haggard, pale, emaciated, it began, slowly, to rise from the floor, growling like some glutted hyena at being roused from his lair. It stood, at length, erect before us, resembling more an anatomical preparation than a true and living man. "Thus I am served," muttered he, "whenever you want my work. But give me something to drink. I must have drink, and I will be contented." This was the executioner! Yes, we stood in the awful presence of a minister of justice, and we shrunk with reverential horror at his glance.*
>
> *Again and again, he entreated to be supplied with liquor, which was positively refused, though with the assurance that, after the execution, if well performed, he should have as much drink as he desired. A transient, but ghastly smile flickered for an instant on his cheek, when the door was closed again and bolted.*

On February 18, 1820, John and Lavinia Fisher were moved by wagon from the county jail to a gallows constructed on Meeting Street Road, just beyond "the lines." An enormous crowd assembled to watch two of Charleston's most infamous murderers meet their just fate.

One writer described the spectacle of the crowd assembled for the hanging:

> *Staid merchants were there, inwardly surprised at themselves for coming, and with them were dandies with...extravagantly cut pantaloons; coonskin-capped wagoners; soldiers from the garrison at Fort Johnson; Dutch, French and Spanish seamen; country cousins who had come to town for Race Week and neglected to go home again; free Negroes with their plump mulatto wives; slaves and white apprentice boys, all gathered around the gibbet. Little masters and misses broke from their nurses and...trudged to the hanging. Here and there were even fashionably clad women...The keepers of grog shops and sailor's boardinghouses in Bedon's Alley were there. The girls from the houses near the jail were there on their best behavior.*

John Fisher appeared quiet and prepared for his sentence to be carried out. As Lavinia Fisher was escorted to the gallows steps, she screamed and fought to avoid being taken to the necessary place atop the wooden structure.

Charleston's Trial

When she refused to yield, the deputies had to restrain her and carry the reluctant prisoner up the steps.

Once Lavinia was in place, she composed herself, and before the hood was placed over her head, she looked out at the uneasy crowd. Legend holds that, with a glare of indignation, she yelled, "If you have a message you want to send to hell, give it to me—I'll carry it." However, first-person accounts of the hanging clearly indicate that she had no statement for the crowd. Like most people facing their own demise at the end of a rope, Lavinia was scared and lacked the bravado that tour guides love to suggest.

The executioner, still reeking of alcohol and sweating through his pores in the morning sun, pulled the lever to send husband and wife to eternity. He then turned to the sheriff, begging for his promised reward of drink.

Another hanging in 1820 captured both the attention and imagination of the Charleston sheriff. Crewmen George Clark and Henry Robert Wolf were charged and convicted of piracy while aboard the Buenos Aires ship *Louisa*. The trial was held in Charleston, and the condemned men were sent to the county jail to await their prescribed fate.

True to the naval tradition, the executions for piracy would take place aboard ship, even though the ship would be docked at the Charleston wharf. The *Louisa* had long since disembarked, so arrangements were made for the executions to take place aboard the U.S. schooner *Tartar*.

On the morning of May 12, 1820, a yellow flag was run up the foretop masthead, the traditional signal for an execution. Just before 11:00 a.m., the prisoners were loaded into a carriage and followed Sheriff Francis Deliesseline and several armed deputies on horseback.

Upon arrival at the ship, the condemned men were spirited aboard and stood on deck for the brief ceremony. A noose was placed around the neck of each man, secured to a rope that ran through blocks at the yard arms. The rope looped back down to the side of the ship and was tied to heavy weights suspended and secured there. Upon signal by the captain, the lashings holding the weights were cut away, allowing the weight to fall into the water and propelling the prisoners violently into the air, breaking their necks in the process.

The *Charleston Courier* reported:

> It was an awful scene—and the mode of execution being entirely new to the great body of our citizens, together with the great interest excited by the nature of their crimes, drew together an immense concourse of people—the wharves, shipping and stores, within view, being filled with spectators; and the harbor covered in boats in all directions.

Snatched...To Return a Corpse

Sheriff Deliesseline was fascinated with this method of hanging, jerking a prisoner into the air to break his neck as opposed to dropping the prisoner from an elevated gallows. He would experiment with this method for hangings at the jail yard in the future.

In 1822, another infamous tale of Charleston crime and punishment occurred when William Paul, a slave, told Peter Desverneys, another slave, of an insurrection being planned in which armed slaves intended to kill white families in the hope of freeing themselves. Desverneys eventually shared this information with his master, who promptly notified the authorities.

Paul was arrested and interrogated until he named several of the conspirators. The story given by Paul sounded too spectacular, leaving the city officials leery of its accuracy. Nonetheless, authorities asked a trusted slave to speak with the named conspirators to learn the truth. After investigation, this "spy" reported that, in fact, an armed uprising had been planned for June 16.

A large force of armed white men patrolled the city, arresting the named conspirators and many others for questioning. Rumors permeated the city and neighboring plantations, making citizens uneasy. By the completion of the investigation, 131 slaves and free blacks had been arrested. A city slave, Monday Gell, identified Denmark Vesey, a free black and carpenter, as the ring leader of the planned uprising.

A special court, the Court of Magistrates and Freeholders, was convening to take evidence and determine the fate of the many blacks arrested. Vesey and five slaves were the first to be convicted and executed on July 2, 1822. By the completion of the investigation, thirty-five blacks were hanged and thirty-one were banished for their roles in the planned insurrection.

The fear of such an insurrection in a city in which blacks outnumbered whites resulted in the passage of a number of laws to further protect the white citizens of the city. Citizens could no longer choose to free their slaves; free blacks who left the city and later returned could be enslaved; all black males over the age of fifteen had to have a white guardian or be enslaved; and the movement of free blacks was restricted. The Charleston City Council petitioned the state legislature for an arsenal or "Citadel" to be constructed to provide for safety in the city. This led to the construction and opening of The Citadel, later chartered as the South Carolina Military Academy.

While the weight system is believed to have been used much earlier, the *Charleston Daily Courier* reported the specifics of this new hanging method in 1859. On March 25, 1859, Richard Foster was executed in the yard of the Charleston County Jail. The reporter recorded:

Charleston's Trial

At 3:12 pm, the iron trigger which supported the heavy weight suspended over a pit, was released by a touch of the official appointed, and the body of the convict was shot upward. In less than a minute—we believe about forty seconds—all signs of life and motion and sensation had ceased.

From that point on, until hangings were abolished in favor of the electric chair in 1912, Charleston sheriffs employed the "weight system" to execute their prisoners.

When Duncan was sentenced to death in 1910, Charleston had not witnessed an execution since William Marcus was hanged in 1906. Marcus was arrested for the brutal murder of his wife, stabbing her forty-two times through her head, body and arms with an ice pick. Once arrested, he accused his wife of having an affair with a soldier stationed at Fort Moultrie and passing on a venereal disease she contracted from him, though a postmortem examination of the wife did not reveal the presence of any venereal disease. Marcus was tried, convicted and sentenced to die by hanging.

More than five hundred people crowded into the jail yard to witness the spectacle of the execution. The *News and Courier* printed the account of the hanging:

It was an impressive and a terrible sight. Father Duffy continued to read prayers to Marcus to which he responded. There was a pause between the completed preparation of Marcus for execution and the signal for the ketch to be sprung. Men held their breath in that moment. Somewhere in that mysterious box at the right of the doomed murderer there was a man waiting for a signal, which was to dispatch a heavy iron weight set high up in the box. He had but to pull a lever and the weight would drop. It would pull a rope to which Marcus was attached with a deadly knot under his left ear, and then the erect and bound figure would be snatched from the ground to return a corpse.

No unnecessary time was lost for the fatal signal. Sheriff Martin was behind Marcus, and it was his duty to give the word for the execution. Without a motion, Marcus waited for the jerk. Suddenly, noiselessly, cleanly, the body of the man left the ground. It rose smoothly into the air toward the cross beam of the gallows. Then it dropped a few feet back near the ground. It was then nine minutes past 11:00 am. The return jar was followed by a slight crack, which broke Marcus' neck.

There was no special convulsive movement at first. The hands twitched a little and the legs drew up a bit. Following this movement, the body began to tremble sharply from head to foot and then became still.

Snatched...To Return a Corpse

In 1859, the Charleston County sheriff changed his method for execution by hanging using the system to hang condemned men aboard ship. *Courtesy of the late Dr. Emmett Robinson, College of Charleston.*

Charleston's Trial

Using this method, the condemned man stood on the ground connected to a five-hundred-pound weight located in a closed box. *Courtesy of the late Dr. Emmett Robinson, College of Charleston.*

Snatched...To Return a Corpse

Upon receiving the signal of the sheriff, the executioner pulled a lever, releasing the weight to drop and yanking the condemned man into the air. The return drop was intended to break the neck of the prisoner. *Courtesy of the late Dr. Emmett Robinson, College of Charleston.*

> *A step-ladder was brought out a few minutes later after the ketch was sprung and Dr. Bellinger, the jail physician, climbed up to make the death test. He placed his ear to the breast of the body and detected a faint fluttering of the heart. Marcus was almost dead. Dr. T. Edwards, who is visiting in Charleston, also made the test and at nine minutes after the body was swung into the air, it was pronounced inanimate. Sheriff Martin had the yard cleared when Marcus was pronounced dead.*

Dr. Bellinger and Dr. Edwards examined the body after it was cut down, determining that, in fact, the neck was broken. Typically, using the weight method, the condemned man loses consciousness quickly and the nerve centers are the first to be affected by the violent jerk. In this manner, the hope is to kill the man quickly rather than subjecting him to death by strangulation. Given that the average time for death by this hanging method is fourteen minutes, with the death pronouncement given at the nine-minute mark, the doctors and the sheriff concluded that Marcus's hanging was one of the most orderly and efficient.

After all official duties were concluded, the body, with the black hood still in place, was put into a coffin and delivered by wagon to McAlister's Funeral Home, which conducted the burial the next day. A new half-inch hemp rope was used for each hanging. After the body was cut down, the rope was given to the sheriff's deputies, who would then cut it into small pieces and sell the gruesome souvenirs to citizens gathered in the yard and around the jail.

With the furor over the murder of Max Lubelsky and the public's rapt attention as Duncan's execution date neared, the deputies surmised that the hanging rope in this case would bring a pretty penny.

CHAPTER 17
I Will Not Die with a Lie on My Lips

After Duncan adjusted his eyesight, gazing upon the vibrant garden and colorful wildflowers, he turned his gaze to the courtyard and the mass of deputies assembled by Sheriff Martin. Rural policemen John Burton, Thomas Kelly, Andrew Nelson and several other men deputized for the day now joined the staff who arrived with Sheriff Martin.

Outside the jail, the atmosphere was lively. Street hucksters hawked rice cakes and monkey meat, a candy made with coconut and molasses. Everyone, from banker to dockworker, was in attendance. Jurors Robert Lebby and Lawrence Bicaise found each other in the crowd.

Spanish seamen, in port for several days, were joined by soldiers who came over from Fort Moultrie. Businessmen, who would deny their attendance to churchgoing wives, mixed with kids who had escaped the watchful eyes of their mothers.

The jail was bordered on Magazine and Franklin Streets by a number of Negro homes operating as bordellos. Beyond the available beds and pallets, prostitutes sold tickets for use of the upper-level piazzas to those wanting to peer over the walls of the jail.

Duncan could see part of the crowd through the double gate just outside the jailor's office. Even as he moved past the gate, he could hear and feel the presence of the large crowd. He could see the many people who had climbed to the upper porches and rooftops of the nearby buildings to witness the private spectacle from on high. Elevated observers shouted down to the crowd below as the condemned man entered into the light of day. Even the large and excited crowd became eerily hushed, as they knew Duncan had arrived for his final walk.

Sheriff Martin and Reverend Nichols led the procession; a procession unlike any other for the good reverend. A jailor carrying the half-inch hemp

Charleston's Trial

The western gate at the Old Charleston Jail outside of the jailer's office. Daniel Duncan first stepped outside the jail here to begin his walk to the hangman. *Author's collection.*

rope with the hangman's noose followed the threesome. Behind him were the other black ministers and the appointed "expert observers."

The solemn procession walked along the west side of the jail. Not a word was spoken. Once Duncan walked far enough to see the octagon-shaped portion of the jail on the south end, he came into full view of the prisoners straining to see him through the small windows of the jail.

The women prisoners housed in the southwest corner began a "bloodcurdling howl" at the site of Duncan. Their screams and howls unnerved the crowd surrounding the jail on the streets. Even with this unexpected and unsettling response of the women prisoners, Duncan continued his walk, oblivious to the chaos.

The moaning and wailing from the female inmates carried some distance, loud enough to be heard through an open window at the Medical College of South Carolina at Queen and Franklin Streets. Though he was fully aware of the scheduled hanging and knew his lecture room held a full command of the gallows, one professor at the medical college was determined to hold class. As he moved through the morning's text, he was distracted by a student near the window who craned his neck to take in the scene unfolding nearby.

I Will Not Die with a Lie on My Lips

The professor called out to the distracted students, admonishing them to focus on the lessons at hand. As the professor turned back to face the blackboard, the wailing continued, rallying the attention of the other students. The professor ventured to the window himself to take in the scene. Now the entire class strained to see.

This time, the professor acknowledged his defeat. He invited the class to join him at the windows overlooking the jail and began to explain the physiologic process of an execution by hanging.

The professor pointed to the yardarm with the noose and the rope running into a small shed behind it. He explained to the students that the rope connected to a five-hundred-pound weight suspended over a hole. At the appointed time, the sheriff would nod to the executioner, who would then release the lever, dropping the weight. The condemned man would be violently jerked into the air.

Responding to questions from his inquisitive young charges, the professor further explained that it is not the pull up that kills you—it is the drop back down. The weight pulls the man into the air, and as he falls back down, the rope abruptly ends his descent, in theory, at least, snapping his neck. Typically, this hanging method severs the spinal cord, which functionally decapitates the condemned prisoner. Sometimes the hanging creates a high cervical fracture. In this case the prisoner may not even lose consciousness right away. Death by strangulation can take several minutes to as long as a half hour before the heart stops. During strangulation, even though the prisoner may be unconscious, the body and limbs may be moving due to nervous or muscular reflexes.

The entire class listened intently, but never removed their stares from the hanging procession making its way around the jail.

Finally, the slow procession reached the back of the jail building and turned east to walk to the gallows on the far side of the yard. With the continued screaming of the women, the huge crowd assembled on the streets now became restless and uneasy. Though it was difficult to hear, the crowd continued to receive updates from those on the rooftops who were able to see over the wall and inside the jail yard.

Duncan looked around the yard at the few permitted guests and official observers, as if to record their presence, but he did not speak or show any signs of panic. Among the observers was the one reporter allowed to attend from the *News and Courier*. As the procession approached the gallows, Daniel Duncan nodded in the direction of the reporter.

He then looked in the direction of the hangman, nodding and walking to him. Though his arms were bound to his side, Duncan tugged at the rope

to attempt a handshake with his executioner. The executioner, known to everyone but Duncan, still wore the traditional hood over his head, providing a shroud of anonymity that covered everything except the executioner's eyes, which were tired and bloodshot. Understanding the prisoner's intention, the hangman took hold of Duncan's fingers, squeezing them briefly, but gently.

On reaching their destination, Martin turned Duncan around to face west and tied his legs at the ankles. Martin asked, "Daniel Duncan—do you have any final words before the order of the court is carried out?"

Sturdy in his response, Daniel Duncan looked at the few observers and stated in a low voice, "I will not die with a lie on my lips, I am an innocent man. I'll wait to meet you all in heaven."

Martin shook his head, struck by the cordial manner in which Duncan was handling the whole affair. No last-minute confession; no hysterical response. Duncan was resolute in maintaining his innocence.

With the necessary formalities concluded, Sheriff Martin motioned for the executioner to secure the black hood. As the executioner placed the hood over Duncan's head, Duncan smelled the stench of alcohol and sweat coming from the executioner. The cloth of the hood was thick and coarse and smelled musty. Even with his eyes wide open, it was black as night inside the hood. Duncan's breath came out hot as the air inside quickly became thin. He could feel the heavy weight of the noose being positioned around his neck and the pressure of the knot as it pressed against his windpipe.

Finally, at thirty seconds past 11:00 a.m., all preparations were complete, and they were ready to proceed with the execution. The executioner took his position in the box, awaiting his order.

Duncan had worked hard to retain his composure throughout the day. Before the hangman could pull the trigger on the weight, however, Duncan swayed to one side and fainted without a sound or a word. The reporter later reported that Duncan's fainting was "due to a weakening of the heart." The intensity of the moment was palpable. Martin cursed at the intrusion of an unplanned event.

The rope did not have enough length to allow Duncan to fall to the ground. Rather, he collapsed to a semi-standing position, with his knees bent, but his torso and head pulled up by the stress of the rope. Several sheriff's deputies rushed up to Duncan to ensure that the rope was not entangled. Upon seeing that the rope was clear, they nodded to Sheriff Martin. Martin looked at all assembled and said, "He doesn't have to be conscious to fulfill the sentence."

With Duncan still unconscious but secure in the noose, Martin gave the signal. As instructed, the executioner sprung the weight, which dropped five

feet, summarily jerking Duncan up into the air. The heavy weight made a loud thud easily heard across the wall. It was 11:01 a.m.

The rooftop lookouts, at first, did not speak; their report was unnecessary. The crowd knew the weight would propel Duncan to his death. The crowd's reaction was a mix of gasps and some cheers initially, and then silence enveloped them again as they waited to hear that the convicted man was, in fact, dead.

Nichols and his band of ministers all offered their prayers. At the moment the weight sprung, Nichols looked upon his latest convert with tears streaming down his face. Those in the jail yard waited to hear Duncan's neck crack as his body dropped, but after the thud of the weight, there was no sound.

Duncan's head was pushed to the right side by the rope. The severe jerk and the return fall, however, did not sever his spine as was intended. Death was not instantaneous. The official witnesses, as well as those on the rooftops and the classroom of medical students, could see his legs contract several times as his body spasmed and his hands flinched.

The ministers, now all looking upon Duncan, fell to their knees, praying, as if on cue. It seemed interminable; soon the body began to sway slowly back and forth.

With no announcement that he was dead, the crowd on the street grew impatient, calling for a report. Minutes passed with no declaration.

At the medical school, the students grew uneasy and turned to their professor for an explanation. The professor looked over his brood and exclaimed that the execution did not go as planned. He confirmed that they were watching a man strangle to death. He may have fractured his neck, but the weight did not do its job.

For a full five minutes, no one in the jail yard spoke aloud other than the soft prayers offered by the ministers. Martin looked at each of his charges, one by one, as if to say, "Stand still." The executioner emerged from the confines of his box, wondering if he had done something wrong.

The full group of official observers was drenched in sweat as they stood still in the hot July sun. Time seemed to slow down as they all watched Duncan swing slowly at the end of the rope. After another fifteen minutes, even the deputies grew restless.

The reporter surveyed the small crowd, sweeping his eyes around the yard. The ministers continued their prayers, now with heads bowed. Every white man in the yard simply stood still, staring as if they were following some unspoken rule of hanging etiquette. They all had their eyes fixed on Duncan, watching him swing.

Charleston's Trial

The reporter pondered the newspaper's coverage of the debate taking place in the state legislature over execution by electric chair. The proponents asserted that death was instantaneous, whereas death by hanging was, in most cases, unpredictable and cruel. Opponents staunchly defended hanging because it was horrific and served as a deterrent to crime. Those in the yard, in the classroom and on the rooftops agreed on one point—it was cruel and gruesome to watch.

The body of Daniel Duncan continued to hang under the hot July sun for a total of thirty-nine minutes. Finally, Sheriff Martin asked the county doctor to verify his death. Climbing a ladder to reach the body, the doctor conducted the "death test," which consisted of no more than the placement of his ear to the chest. He pronounced Daniel Duncan dead.

CHAPTER 18
WILDFLOWERS

Reverend Nichols handed a written statement from Daniel Duncan to the *News and Courier* reporter who was present. It was Duncan's request that his last statement be published for all to read.

The sheriff instructed the deputies to cut the body down, and in doing so, the deputies removed the hemp rope from the dead man's neck on one end and from the five-hundred-pound weight on the other. The long rope was quickly cut into pieces and divided amongst the deputies, who slipped outside, several at a time, to sell the hanging souvenirs.

Martin waited for the large crowd outside the jail to disperse before releasing the body to Reverend Nichols. Duncan's body was placed in a plain wooden box for burial. Nichols made his way through the gate to find his son, Ward, still waiting with their buggy. The deputies placed the coffin on a buckboard wagon, covering it with a tarp to avoid undue attention.

The small funeral procession consisted of Reverend Nichols and his son in their buggy, followed by one sheriff's deputy on the wagon transporting the body. Though the wagon lacked the trappings of a hearse, everyone on the route from the jail to the AME cemetery at the Three Mile House knew that simple wagon transported the body of the murderer.

Arriving at the cemetery, the small party was met by the gravedigger, who already had the site prepared. It was no small irony that the site of the Morris Brown Cemetery overlooked the Jewish cemetery bearing the grave of Max Lubelsky. Without delay or ceremony, the plain coffin was placed in the ground, and Nichols, his son and the deputy watched as the gravedigger quickly filled the open grave. Once the grave was fully covered, the deputy promptly left the cemetery in his wagon.

Reverend Nichols, opening his prayer book, read an appropriate passage over the grave and then turned to walk back to the buggy with his son.

DANIEL DUNCAN DID NOT CONFESS

Claims Innocence in Sealed Letter Opened After the Execution

URGED BY PASTOR TO TELL THE TRUTH

Letter Probable Cause for False Reports of Confession by Negro

Headlines in the *Charleston Evening Post*, July 8, 1911. *Courtesy of the Charleston County Public Library.*

Suddenly he stopped, picked a nearby wildflower and returned to the freshly covered grave. Stooping down, he made a hole in the loose dirt with his finger, inserted the wildflower and pushed the dirt back around to support the simple homage to the deceased, now home in an unmarked grave.

Alone with his father for the ride back to town, Ward Nichols pondered the issue of this dead man's guilt or innocence, a topic he had heard his parents discuss many times over the last year. When his son asked for his opinion, Reverend Nichols explained the process he used with any prisoner to make peace with themselves and their God. Conjuring a vivid picture of hell and damnation for those that lie, he explained that he could usually get even the toughest to tell him the truth. Throughout the year in jail, and up to the hanging itself, Duncan maintained his innocence. He explained to his young son that yes, he believed that Daniel Duncan was innocent. However, as the wagon continued on into town, the reverend stated to his son, "Only God knows who the saints and sinners really are—only God knows for sure."

The Saturday edition of the *News and Courier* published the letter Duncan gave to Reverend Nichols. Anticipating that the statement might contain

WILDFLOWERS

Duncan's final admission of guilt, Charlestonians were anxious to read the letter. They were quite surprised and disappointed to read Duncan's actual statement.

> *Gentlemen: How can you have the heart to stand to see the advantage taken of a poor man for nothing? But anyhow that will be all right. I leave it between you and the good Lord. He knows it all. Tell Mr. Cross who went down to the court house and kiss the Bible and say that I was the man he saw in the shop, which he know was a lie. But tell him that is all right. We will meet one of these days and we will talk the story over. I ain't have no evil in my heart for him. I ask the Lord to forgive him, and have mercy on him, because I want him to meet me in heaven, because I know that I am saved. I feel like a changed man. I was praying for this day to come so I can see my Lord and my mother. She is waiting to receive me in the Kingdom, because I know that she is there. She is preparing a place for me.*
>
> *I must congratulate Capt. Hanley. Ever since I were in here, he sure did treat me fine. Anything that I want I ask him for, he will be sure to let me have it, therefore I ask the Lord to help him, that I may meet him in heaven. Also Capt. Rice. He sure treat me like a gentleman. Also Mr. Strobel. I hope I will meet them in heaven. I know that I am going there to rest. My dear father did all he can for his dear son. He could not do anymore. I am well pleased with him for what he has done for me. Therefore I am going to prepare a place for him to meet me and my dear mother, also my sisters and my dear brother. Tell them that I am at rest, because I am innocent, and the Lord knows that I am today. It is nothing but dead advantage taken of me, for something that I don't know nothing about. But anyhow that will be all right. I will meet you when the roll is called.*
>
> *Daniel Duncan*

On Sunday, July 9, two days after the hanging, blacks from all across the city poured into the Morris Brown AME Church to hear Reverend Nichols's account of the tragic hanging of Daniel Duncan, who they all believed to be innocent. On that bright Sunday morning, you could not have squeezed one more horse and buggy on the street for blocks around the church. The excited congregation soaked up all the words of the reverend describing the injustice that had taken place, while Ward Nichols sat daydreaming, drifting back to the simple, sad burial, the lone wildflower atop the unmarked grave and the two victims, Lubelsky and Duncan, in their final resting places not fifty feet apart.

Charleston's Trial

In the days following the hanging, rumors were wild through the city about a letter reportedly given to Reverend Nichols by Duncan before he was prepared for the walk to meet the executioner. Disappointed that Duncan's prepared statement to the *News and Courier* did not include a confession, the public concluded that the letter for Nichols would bear the "truth."

Though the letter given to the pastor was intended to remain private, Nichols decided to release it so as to put an end to the public drama. Everyone was shocked and again disappointed to learn that this "private letter" was consistent with the previously released statement.

CHAPTER 19
THE JUDGMENT OF MAN MEETS THE WRATH OF GOD

In the weeks after the hanging of Daniel Duncan, the city returned to its normal pace, facing all the same issues as before the 1910 murder of Max Lubelsky. By August, conversation about the hanging had disappeared in the daily debates from King Street to the docks.

Unhappy with the "put up job" on Duncan, the Lubelsky store at 543 King Street became the object of a quiet protest as blacks refused to walk in front of or shop in the store. If passage on this block of King Street was necessary, blacks would cross, walking on the east side of King Street, even though the store was no longer operated by the Lubelsky family.

There remained a lingering tension between black customers and Jewish merchants in Little Jerusalem. With no real options elsewhere, though, buying habits quickly returned to a business-as-usual posture for both the merchants and their Darktown customers.

As summer neared its close, the two most important crops, rice and cotton, were nearing harvest. The cotton was open and sitting in the fields, ready for picking. Carolina Gold Rice, up and down the Ashley and Cooper Rivers, was glimmering in its golden color, showing the time for harvest had arrived.

Many white residents were busy enjoying the last of summer vacation on Sullivan's Island and Isle of Palms. The last of the "summer people" were returning from the North Carolina mountains, where their summer homes had offered a respite from the heat and humidity of Charleston.

Captain Walls, commanding the schooner *Fortuna*, looked forward to a good trip to New York as his ship eased out of Charleston Harbor on Saturday afternoon, August 26. The hold was loaded with 485,000 feet of lumber for the Tuxbury Lumber Company. No one at the docks or the Weather Bureau had paid much attention to a low pressure system in Florida as it moved out to sea.

Charleston's Trial

Men enjoying a Sunday afternoon at Sullivan's Island. *Author's collection.*

As Charlestonians went to bed on Saturday evening, the night offered clear and starry skies. By midnight, however, clouds began moving in and the wind picked up slightly. The dawn on Sunday morning brought cool temperatures, with rain and a thirty-mile-per-hour wind.

Wind conditions were static through the morning, but the dropping pressure, as witnessed on the barometers, gave cause for some concern. By midday Sunday, a telegram from Chief Moore with the U.S. Weather Bureau in Washington issued the following message: "Storm still apparently off the South Carolina and Georgia coast. Intensity unknown. May develop hurricane force. Advise all interests to take necessary precautions. Order for Savannah and Charleston. NE storm warnings for Jacksonville."

The Clyde Line steamer *Mohawk* arrived from Jacksonville en route to New York at 8:30 a.m. with a ship full of passengers, and all aboard reported a rough trip into Charleston. The ship was scheduled to depart for New York at noon, but by midday the shipping company officials announced, to the relief of the continuing passengers, that the ship would remain in Charleston for the day or until the rough weather subsided.

The Judgment of Man Meets the Wrath of God

Charlestonians began moving their boats and sailboats upriver on both sides of the peninsula, seeking refuge from the declining conditions in the harbor. The pilot boat was moving like a sentinel through the harbor, monitoring the movements of the small craft heading for shelter. The pilot was also watching the harbor entrance, looking for a passenger ship, the *Apache*, due in from New York and a United Fruit Company banana boat, the *Beatrice*, due from Jamaica.

By midday Sunday, there were still fifteen hundred "excursionists" enjoying the facilities on Isle of Palms, determined to ignore the deteriorating weather conditions. Superintendent Passailaigue, of the Consolidated Company operating the amusements and facilities on Isle of Palms, ordered the evacuation of the island by midafternoon.

In the city, throughout the afternoon, Mr. Cole, with the U.S. Weather Bureau, was witnessing the steady rise in the wind speed and decrease in the barometric pressure. At 3:45 p.m., he hoisted the red flag with a black square in the middle, the traditional signal for a hurricane warning, atop the flagpole at the U.S. Customs House on East Bay Street. Through the intense wind and rain, no one would be able to see the signal. Cole fielded hundreds of telephone calls, now notifying everyone of the arriving storm.

The Ferris wheel at the Isle of Palms was a popular summer amusement in the early twentieth century. *Courtesy of Danny Peterson.*

Charleston's Trial

When a hurricane was threatening Charleston, a flag was raised over the Customs House on East Bay Street to warn the city's residents. *Author's collection.*

People in the vicinity of Broad Street initially thought small hailstones were falling, but they soon identified the damaging missiles as the small gravel from atop the People's Building, Charleston's version of a diminutive skyscraper. Large sheets that once were stretched across King Street, advertising department store sales, were now blowing through the city like giant kites that could not quite get airborne.

At 5:00 p.m. on Isle of Palms, eight hundred people boarded the ferryboat *Lawrence* for the short trip to Charleston, but found the journey harrowing. The overloaded boat slugged its way through the rough water, at times literally unable to advance against the wind and waves. The large crowd could not all fit under cover, leaving many passengers to brace themselves against the blowing storm.

It looked as though the struggling boat might not be able to reach the normal platform at the docks, making landing upriver at the Southern Railway piers more likely. Much to the surprise of everyone onshore in the city, and to the pilot's boat holding vigil in the harbor, the captain did make a successful landing at the regular dock, even as the ship pitched severely in the wake.

As soon as the gangplank was secure, connecting the ship to the dock, hundreds of panicked passengers bolted from the ship. A number of women and children were injured in the crush of the crowd. Children were screaming

The Judgment of Man Meets the Wrath of God

uncontrollably, some from fright, some from being trampled. As the determined crowd kept pushing to the exit, several women fainted, collapsing against the wall-to-wall bodies, but unable to fall for lack of room to do so. Remarkably, everyone left the boat either on their own or carried by others.

As the *Lawrence* was unloading, another ship, the *Sappho*, and the lighthouse tender *Cypress* arrived at the adjacent docks, ferrying passengers evacuating Sullivan's Island. The captain of the *Lawrence* moved his ship back to the harbor to attempt a second trip to the Isle of Palms to retrieve the remaining stranded people awaiting his return. As rough as the trip to the city had been, this return trip, now steaming into the face of the storm, proved impossible. Unable to even reach Mount Pleasant, the *Lawrence* had to turn back, effectively stranding hundreds of people on the narrow strip of sand.

Coming in from the ocean, the captain of the *Apache* could see Fort Sumter ahead. With rough seas, the large granite rocks that formed the two sides of the jetties stood as a formidable obstacle that had to be navigated to reach the inner harbor. As he started his ship through the channel, he quickly realized that he could just as easily end up as debris amidst the rocks as make it through. Returning to deep water, the captain decided to ride out the storm on the ocean outside the harbor.

As the gray light of day gave way to darkness, Charleston was soon to be prisoner to the advancing hurricane, now clearly bearing down on the port city. At the Customs House, Cole knew the night would prove to be a disaster as the brunt of the storm and high tide would likely arrive at the same time, exaggerating the conditions to befall the city.

The increasing winds swept across the city, ripping off the slate and tin roofs and sending the debris to the streets below. Panicked citizens could hear the many brick chimneys give way as they crashed on rooftops, adjacent buildings and the streets. By 9:30 p.m., the streetcar, telegraph, telephones and electric light services were all out, leaving Charleston cut off from any communication.

A reporter from the *News and Courier* wrote that "the steeple of the church [St. Michaels] swayed so much during the storm that the bells were occasionally tolling a mournful dirge as property was being wrecked on all sides." Doors to many buildings were blown open, leaving the contents of the homes and businesses to suffer the torrential rain, and now the floods, escorted in by the high tide to engulf the city. Duncan Heyward, at home near the Battery, watched the storm from his upper-level piazza. He wrote, "I saw the ocean actually come up Meeting Street, until all the lower part of Charleston was under water."

CHARLESTON'S TRIAL

The 1911 hurricane hit Charleston hard, leaving much damage to buildings in the city and devastating crops in the country. *Courtesy of the South Carolina Historical Society.*

On the Isle of Palms, Passailaigue led the remaining 350 people on the island to the Consolidated Company powerhouse, one of the few solid, brick buildings on the island. At Sullivan's Island, conditions were now desperate as the entire island was underwater, as much as five to six feet deep. The soldiers at Fort Moultrie formed lifelines, holding hands, to pull families from the many cottages across the island. Most people were carried or escorted to the relative safety of the fort to ride out the storm.

By 11:00 p.m., most buildings in lower Charleston had been unroofed, with the windows blown out. Many of the streets south of Calhoun Street were impassible, filled with roof and building debris. The waves were now breaking over South and East Battery, continuing to drown the city, which now stood dark and helpless against the full force of Mother Nature.

At the Customs House, Cole noted the wind speed at ninety-four miles per hour just as the anemometer broke, leaving the weatherman helpless to continue measuring the increasing effects of the storm. By midnight, he noted the total rainfall thus far at 2.6 inches. While the rain was bothersome, everyone along the Charleston coast knew that the demons in this affair would be the wind and storm surge, aggravated by the high tide.

The Judgment of Man Meets the Wrath of God

One resident noted the "noise of falling slate and of tin from roofs and glass and shutters from windows was almost deafening." Hundreds of trees were uprooted in every part of the city, under siege by the relentless storm.

Louis Copleston was aboard the *Apache* trying to ride out the storm in his stateroom on a lower deck. Lying in the upper berth, he watched as his suitcase floated by on the water now rising in his stateroom. Crewmembers had to evacuate passengers from their rooms on the lower decks, at times crashing through the doors with axes. The ship's bilge pumps were fighting what many feared would be a losing battle against the invading water.

All passengers were brought to the salon on the upper deck and issued life preservers. The piano that was bolted to the floor was now sliding back and forth as the ship pitched. A priest aboard began an impromptu service in a vain attempt to comfort the fearful crowd of passengers and crew.

With most of the provisions lost to the water swamping the lower levels of the steamer, the captain instructed the crew to distribute two oranges, a couple of biscuits and a two-ounce vial of brandy to each passenger. The captain also issued an order, offering little comfort but yielding to necessity, instructing each passenger to write his name on a small card, along with the simple statement, "If found, please notify _____," and place the card in his shoe.

A large wave hit the ship, smashing out most of the windows aboard and causing the ship to break loose of the anchor. Now floating at the mercy of the great storm, the huddled passengers braced in the darkness and prayed.

As the terror of the night continued, some respite was offered to the beleaguered city as the hide tide retreated. Heyward, in his book *Seed from Madagascar*, wrote:

> As the water receded, I could see timbers from a wrecked vessel floating down Meeting Street, going out with the tide to the sea. When daylight came, the waves still pounded against the high wall of the Battery, striking with such force that their spray was dashed as far as Church Street, a block away.

As the morning progressed, reports from the many plantations on the Sea Islands and rivers surrounding the peninsula made their way to the city. The entire rice and cotton crop was lost to the wind and salt water. There would be no cash to earn from these fields, only a harvest of despair. Heyward offered that, with the powerful hurricane's arrival, "the death-knell of rice planting in South Carolina was sounded." The crop and property losses would total more than $1 million.

Charleston in Grip of Roaring Hurricane

The Worst Since Memorable Storm of 1893

Yesterday's Turbulence Makes Its Appearance on Eighteenth Anniversary of Last Century Calamity. City Cut Off From All Communication—Official Wind Velocity Reported 75 Miles Per Hour—No Signs of Abatement Early This Morning.

Headlines in the *News and Courier*, August 28, 1911. *Courtesy of the Charleston County Public Library.*

Most of the homes and cottages on Isle of Palms and Sullivan's Island were destroyed. Remarkably, the people stranded on both islands survived, though most with frayed nerves and vows to never repeat the experience. Across the Charleston area, fifteen people were lost to the storm, most killed by flying debris.

As dawn arrived, the terrified passengers and crew aboard the *Apache* were thankful to be alive, but shocked to find that the ship had arrived at Tybee Island, Georgia, during the night. The vessel finally made its way through the jetties, docking in Charleston on Tuesday morning.

The Judgment of Man Meets the Wrath of God

Residents inspecting the damage at the Battery after the hurricane. *Courtesy of the South Carolina Historical Society.*

The *Beatrice* and its load of bananas from Jamaica did not arrive and was never heard from again. The *Fortuna* and its large load of timber, lucky to leave Charleston in advance of the storm's arrival, was also lost at sea.

The city would remain without electric power and telegraph for most of a week, forcing the Western Union to set up operations in Summerville, running messages in and out of Charleston by train. Residents and businesses removed more that twelve thousand wagon loads of debris from the streets.

As everyone took measure of the catastrophe that befell Charleston, most were thankful to be alive. Virtually every building in the city was damaged to some extent, many requiring destruction. After the various natural and manmade disasters to confront the city in the last sixty years, many were left contemplating how much more one community could withstand.

Charleston's black families suffered as well, but they had a satisfaction that white folks did not have; they understood the Hurricane of 1911 for what it was. Generations of African Americans would be raised on the tale of Daniel Duncan and the Duncan Storm: the tempest was God's retribution upon the wicked and sinful city of Charleston for hanging an innocent man.

BIBLIOGRAPHY

Bostick, Douglas W., and Daniel J. Crooks Jr. *On the Eve of the Charleston Renaissance: The George W. Johnson Photographs.* Charleston, SC: Joggling Board Press, 2005.
Brenner, Betty, and J. Francis Brenner. *The Old Codger's Charleston Address Book, 1900–1999.* Vol. VI. Charleston, SC: Jackson's Inc. of Charleston, 2002.
Brooklyn Standard Union. 1910.
Charleston County, Court of General Sessions. *The State of South Carolina v. Daniel Duncan.* 1910.
———. *The State of South Carolina v. Lofton Hansley.* 1911.
Charleston County Library. South Carolina Room, clipping files.
Charleston Evening Post. 1910–12.
Charleston Library Society, pamphlet collection.
Charleston, S.C. and Vicinity. Charleston, SC: Walker, Evans and Cogswell, 1901.
Charleston Yearbook. Charleston, SC: The News and Courier Book Presses, 1900–1912.
College of Charleston. Jewish Collection, clipping files.
Cooper, Thomas, ed. *The Statutes at Large of South Carolina.* Vol. 5. Columbia, SC: State Printers, 1836.
Cuthbert, Robert B. "Research on Robert Mills." Unpublished manuscript.
Earle, Alice Morse. *Curious Punishments of Bygone Days.* Rutland, VT: Charles E. Tuttle Co., 1972.
Emilio, Luis F. *A Brave Black Regiment: History of the Fifty-Fourth Regiment of Massachusetts Volunteer Infantry, 1863–1865.* Boston: Boston Book Co., 1894.
Fraser, Walter J., Jr. *Charleston! Charleston!: The History of a Southern City.* Columbia: University of South Carolina Press, 1989.
Gettys, Elma Johnson. "I Remember." Unpublished.
Hall, Captain Basil. *Travels in North America in the Years 1827 & 1828.* Philadelphia: Carey, Lee & Carey, 1829.

Bibliography

Heyward, DuBose. *Porgy.* Jackson: University of Mississippi Press, 2001.

Hutchisson, James M., and Harlan Greene, eds. *Renaissance in Charleston: Art and Life in the Carolina Low Country, 1900–1940.* Athens: University of Georgia Press, 2003.

Marsh, Blanche. *Robert Mills: Architect in South Carolina.* Columbia, SC: R.L. Bryan Co., 1970.

Moore, John Hammond, ed. "The Abiel Abbot Journals, a Yankee Preacher in Charleston Society, 1818–1827." *South Carolina Historical Magazine* 68 (1967): 51.

News and Courier. 1910–12.

Ravenel, Beatrice St. Julian. *Architects of Charleston.* Charleston: Carolina Art Association, 1964.

Reznikoff, Charles. *The Jews of Charleston.* Philadelphia: Jewish Publication Society of America, 1950.

Rosengarten, Theodore, and Dale Rosengarten, eds. *A Portion of the People: Three Hundred Years of Southern Jewish Life.* Columbia: University of South Carolina Press, 2002.

Scott, Robert N., ed. *War of the Rebellion: A Compilation of the Official Records of the Union and Confederate Armies.* Gettysburg: National Historical Society, 1971.

South Carolina Historical Society. Emmett Robinson Papers.

———. L. Louis Green Papers.

———. Star Gospel Mission Records.

———. WPA Tombstone Survey, Charleston County.

South Carolina State Board of Health Death Index. Charleston County Public Library, South Carolina Room.

Stockton, Robert P. "The Old Jail: A History." Unpublished manuscript.

United States National Archives and Record Administration. *The 1910 federal population census.* 27th edition. Washington: National Archives Trust Fund Board, 2002.

Walker, Peter N. *Punishment: An Illustrated History.* Great Britain: David and Charles Ltd., 1972.

Wallace, David Duncan. *South Carolina: A Short History, 1520–1948.* Columbia: University of South Carolina Press, 1951.

Welsh's Charleston, S.C. City Directory. Charleston, SC: The Welsh Directory Co., Inc., 1910.

White, John Blake. "The Dungeon and the Gallows." In *The Charleston Book: A Miscellany.* Charleston, SC: Samuel Hart Co., 1845.

Williams, Jack Kenny. *Vogues in Villainy: Crime and Retribution in Ante-bellum South Carolina.* Columbia: University of South Carolina Press, 1959.

Wormser, Richard. *The Rise and Fall of Jim Crow.* New York: St. Martin's Press, 2003.